ENCHANTING
SINGAPORE

DAVID BOWDEN

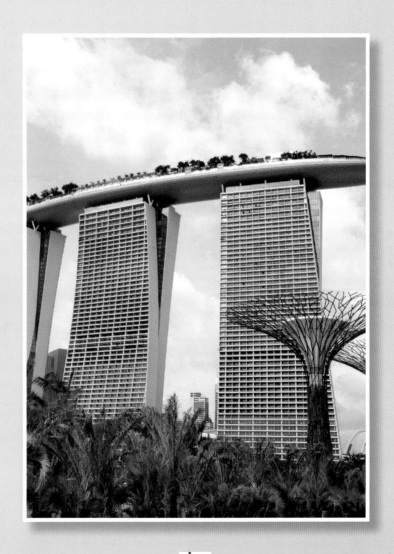

JOHN BEAUFOY PUBLISHING

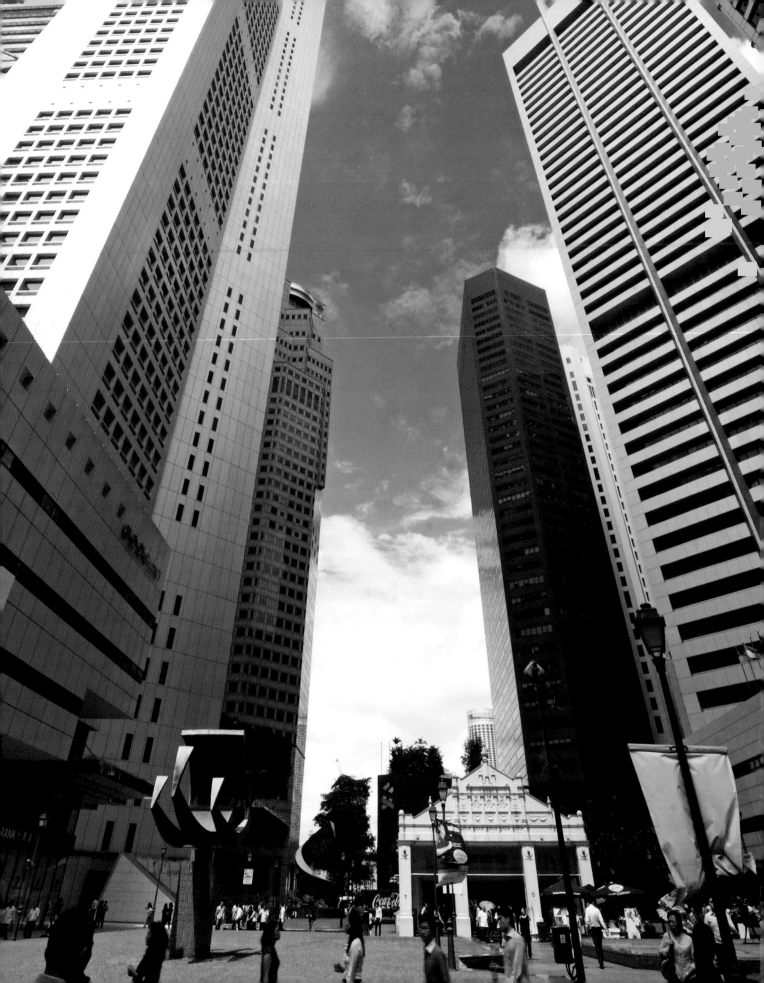

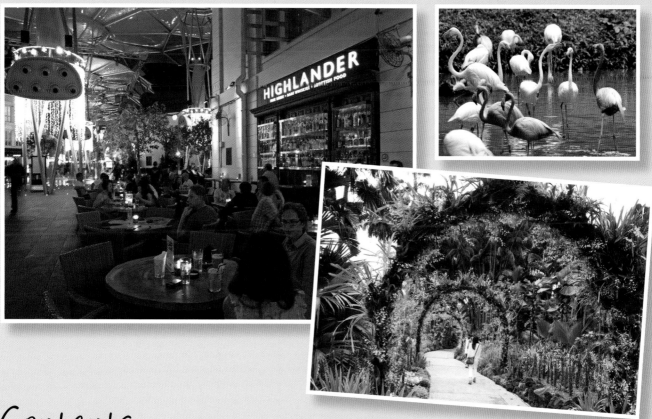

Contents

Chapter 1 **An Island State** 4
Where east meets west

Chapter 2 **Natural Paradise** 32
City in a garden

Chapter 3 **Cultural Attractions** 44
A kaleidoscope of cultures

Chapter 4 **Characterful Districts** 58
An island of neighbourhoods

Getting About, Resources and Index 76

Above: *Colourful flowers and exotic orchids thrive in the Singapore Botanic Gardens.*

Above left: *Singapore has a vibrant nightlife in locations such as Clarke Quay.*

Above right: *Jurong Bird Park is home to hundreds of bird species including flamingos.*

Opposite: *Skyscrapers dominate the central commercial district of Raffles Place.*

Title page: *Marina Bay Sands viewed from Gardens by the Bay.*

Chapter 1: An Island State

In less than 200 years Singapore has moved from being a tropical island covered in forests and with few inhabitants to one of the world's most densely populated islands with one of the highest living standards. While there are parts that retain links to the past, Singapore offers tourists the most Western of all Asian experiences.

Opposite: The commercial district and river are a colourful sight each evening and visible from many city hotels, such as the Fairmont Singapore.

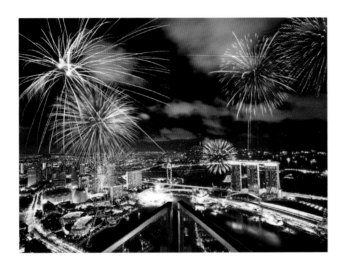

Tourists come to Singapore for many reasons and while the quality of the shopping is important for some, there are many other reasons. Some like to experience Singapore's spectacular attractions with their many parks and rides, others the delicious range of cuisines especially the local Chinese, Malay and Indian dishes; or it could be the variety of accommodation options including some exceptional hotels that is the draw; or perhaps the multiculturalism which can be explored in various districts such as Chinatown, Little India or Kampong Glam. There are also some amazing natural spaces that are home to a wide variety of plants and animals.

Leading the new direction in tourism are the two integrated complexes of Resorts World Sentosa and Marina Bay Sands that offer the glitz and glamour of Las Vegas as well as exciting theme park activities.

Above left: Marina Bay is the venue for fireworks during celebrations, such as New Year's Eve and the Singapore F1 Grand Prix Race.

Above: While one of the most densely populated islands in the world, 47% of Singapore has green cover.

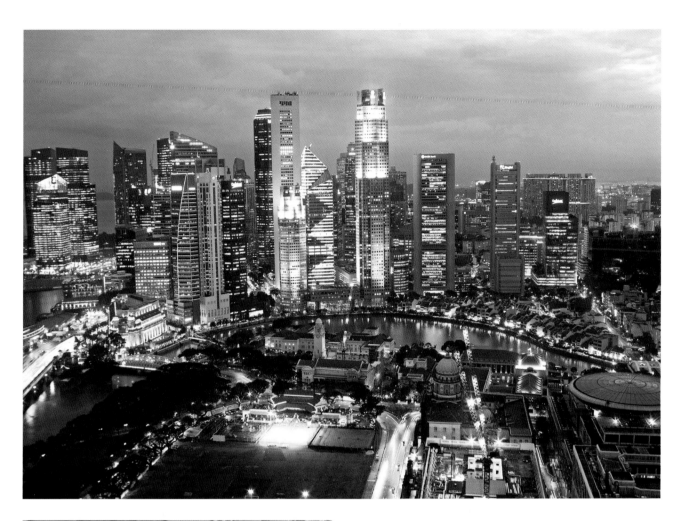

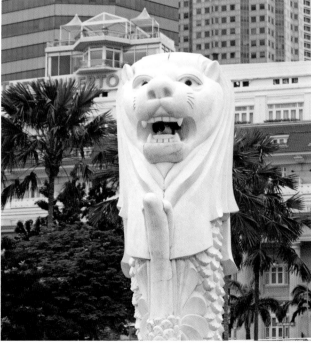

This ensures that Singapore is no longer a place to transit through onto more distant parts although Changi International Airport is one of the world's busiest. Despite its small size, Singapore offers a comprehensive range of holiday activities for extended stays. And whatever the focus of the holiday, visitors can rely on the fact that everything is run with great efficiency and destinations are reached with ease by local public travel.

While Singapore is mostly considered as one island, there are 63 smaller ones surrounding the main island. The second largest, Sentosa, is connected to the main island via a causeway. The other smaller islands are largely unsettled or used for docks and oil refining.

Left: The half fish, half lion called Merlion is the official emblem as commemorated by the statue at the mouth of the Singapore River.

Geography and Climate

Singapore is a member of the ten nation strong Association of South-East Asian Nations (ASEAN) and is bordered by Malaysia and Indonesia. It lies just north of the Equator and 105°E of Greenwich, adjacent to the Malaysian state of Johor and the southernmost point of mainland Asia, and at the southern extremity of the Straits of Malacca, one of the world's most strategic waterways.

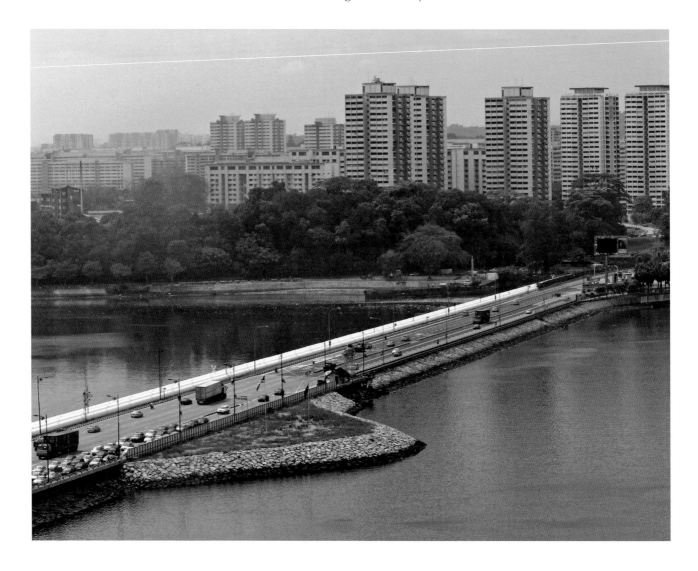

Above: The causeway across the Straits of Johor was completed in 1923 providing road and rail access between Singapore and Johor Bahru in Malaysia.

It has road and rail links to Peninsular Malaysia via a one kilometre (²/₃ mile) long causeway across the Straits of Johor. There is another road link via a bridge at Tuas in western Singapore. The island covers 714 km² (276 sq miles) and is roughly 42 km (26 miles) from east to west and 23 km (14 miles) from north to south. Reclamation has greatly extended Singapore's surface area. It's one of the world's flattest islands: the highest point is Bukit Timah at 163 m (537 ft). Singapore is also one of the smallest nations in the world being ranked 189 out of 236 countries.

The climate is equatorial, which is typically warm and wet year-round. Its climate is dominated by the monsoon. The monsoon is the movement of wind which results from the differences in temperature over land and sea. The word is derived from the Arabic *mausim* meaning season. Unlike countries which experience four seasons a year, tropical countries like Singapore just have wet and dry seasons: the northeast monsoon brings rain from November to March and the southwest monsoon delivers rain from May to September.

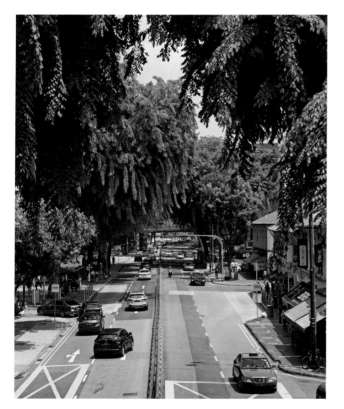

Left: Singapore's equatorial climate ensures lush vegetative cover even in busy urban precincts such as Katong.

Above: The Straits of Johor separate the southern Malaysian state of Johor to the north from Singapore in the south. The border is an imaginary line in the middle of the 50-km (31-mile) long waterway.

History

Singapore is strategically located along one of the world's most significant maritime trade routes connecting the East and West. Goods from India, China and the region passed through Singapore and were then trans-shipped to distant shores. The spice trade in particular was significant and was already well established by the 15th century. Throughout history, ships have refuelled and re-provisioned here and Singapore remains one of the world's busiest entrepôt ports.

During the 14th century Singapore was part of the area of conflict between the kingdoms of Siam (now Thailand) and the Java-based Majapahit Empire who were competing for control of the Malay peninsula. A prince of Palembang, called Parameswara, killed the local chief and enjoyed a short reign before being driven out. It was during his time that Singapore became an important port. Melaka in neighbouring Malaysia came under Portuguese and then Dutch control. By the late 18th century when the British became interested in the region, Singapore was under the rule of the Sultan of Johor. Except for pockets of fishermen, pirates and traders Singapore was then largely deserted. Britain's interests weren't only strategic but also mercantile with the English East India Company securing commercial interests. In 1819, Stamford Raffles, a company clerk, obtained permission from the Riau-Johor Sultan and a local chief to establish a trading post in Singapore, thus marking the start of modern Singapore.

This page: The lavishly decorated houses of the Peranakans (Singaporeans of mixed Chinese and Malay marriage) are best seen in Katong on Singapore's East Coast.

Five years later, in return for payment and pensions, the Malay rulers ceded Singapore to the British East India Company in perpetuity. In 1826 the Company combined Singapore, Melaka and Penang into the Straits Settlements and Singapore developed as a great trading centre that still flourishes today. In 1867 the Straits Settlements became a British crown colony.

Regional goods were imported for processing, repackaging and forwarding to all parts of the world. On the return voyage, vessels took goods to Singapore for distribution throughout Asia. Growing trade demanded workers, entrepreneurs and traders with most migrating from India and China. So while Britain ruled Singapore its population was culturally diverse.

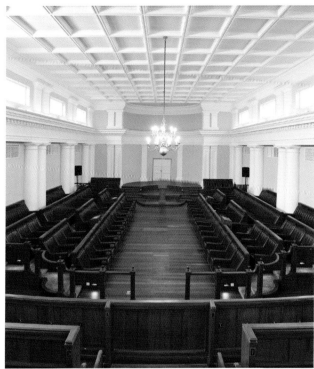

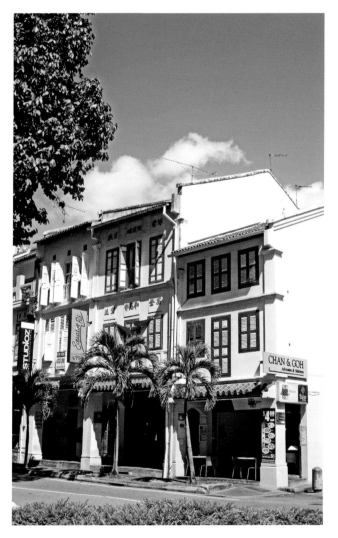

British rule was replaced in 1942 when Japanese forces took control of Singapore and remained there until the Japanese surrender in 1945. In the post-war era, the British returned but the war had fuelled nationalistic sentiment.

In 1959 Singapore was granted internal self-government by the British with the head of the People's Action Party, Lee Kuan Yew, becoming the first Prime Minister. In 1963, Singapore united with Malaya, Sarawak and Sabah to form Malaysia but Singapore separated from this federation on August 9, 1965 to become a sovereign state. Separate democratic elections are conducted to elect parliamentary representatives and the President with the latter's role being mostly ceremonial. The Prime Minister heads up the government.

Left: Many streets in Singapore are lined with old Chinese shoplots where typically business was conducted on the lower floor with the family living on the upper floors.

Above: Originally Singapore's Parliament House, this building has been converted into The Arts House and is now home to the theatre and arts.

The People

Singapore is one of the world's most cosmopolitan societies with a United Nations of ethnicities. It is a nation of immigrants and of its 5.6 million people, only 3.9 million are Singapore citizens. The remaining population is classified as either permanent residents or foreign workers. The government encourages immigration in order to sustain the population since Singapore has a low fertility rate. Singapore has one of the world's highest standards of living and its welfare system is good with a high percentage of the population living in government-subsidized Housing Development Board (HDB) flats.

Of the Singaporean citizens 74.2% are of Chinese descent, 13.4% Malays, 9.2% Indian and 3.2% Eurasian. Some 23% of these citizens were born outside Singapore.

Peranakans who comprise Nyonya (females) and Babas (men) are a race that grew out of the intermarriage between Chinese immigrants (mostly men) and local Malays (mostly women). Peranakans are also known as Straits Chinese and their situation is similar to associated communities in Melaka and Penang in Malaysia in that characteristics of Chinese and Malay cultures were maintained but English was often spoken and Christianity adopted. This enabled Peranakans to become an important link between the colonialists and the locals and as such, many became influential middlemen.

The official languages spoken are English, Chinese, Malay and Tamil but there are also many dialects. Singaporean Mandarin is the most common version of Chinese spoken but Cantonese, Hainanese, Foochow, Hokkien, Hakka and Teochew are also represented. Tamil is the most commonly spoken Indian language although some use other Indian languages. While many Singaporeans are bilingual, public bodies conduct business in English.

Opposite: Many Chinese visit temples to pray and to burn incense or joss sticks to the gods, ancestors or spirits.

Below: Tai chi' is an ancient form of martial arts, now practised for health reasons and it is not unusual to see many performing it throughout parks in Singapore, such as the Botanic Gardens.

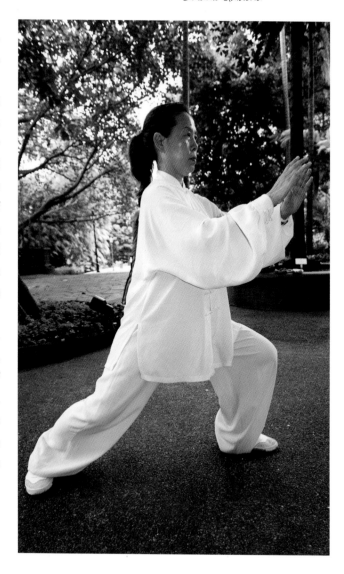

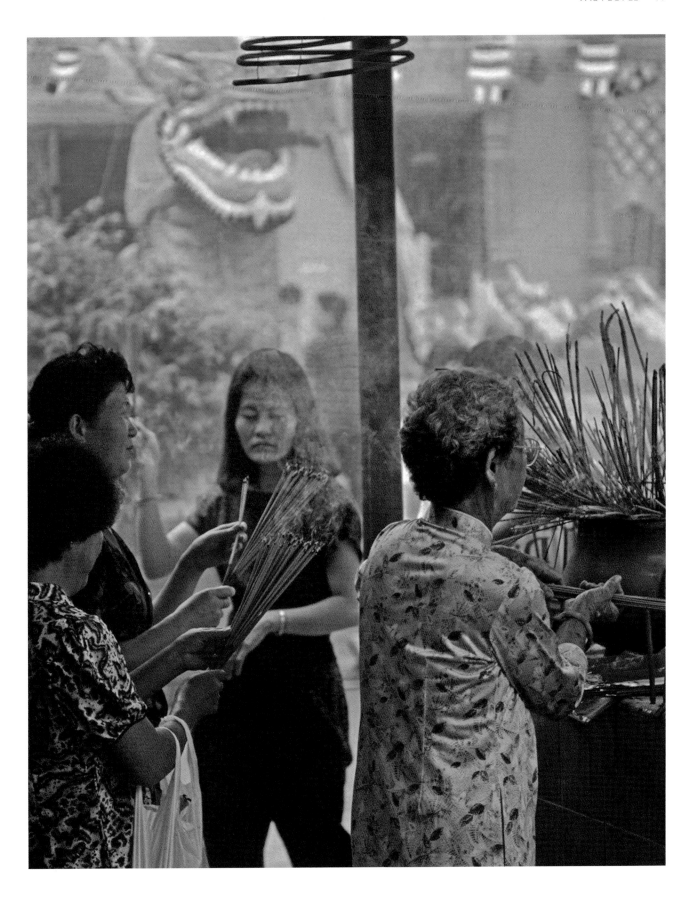

While Singapore is overwhelmingly Chinese, multiculturalism is reflected in its customs and in the religious beliefs of the Muslim, Buddhist, Christian, Confucian, Hindu, Taoist and Sikh citizens. Singapore's cultural landscape is punctuated by temples, churches and mosques while religious festivals for a variety of faiths are held throughout the year.

The holy month of Ramadan is observed by Muslims with month-long fasting and abstinence. At the month's end, Hari Raya Puasa is celebrated with feasting and "open houses". The concept of open house is commonly celebrated by many Singaporeans and involves inviting friends and colleagues over for food and drinks.

Chinese New Year, based on the lunar calendar and falling any time between early January and late February, is one of many festivals celebrated by the Chinese. Most take their main holiday at this time and many businesses close. Many Chinese follow traditional practices by giving red packets (*ang pow*) as gifts, staging lion dances, eating oranges, tossing *yee sang* (raw fish, shredded vegetables and condiments that symbolize prosperity) and having family reunion dinners on the eve of Chinese New Year.

Singapore's Indian community celebrates its own festivities many of which are faith-based. Early in the year, Hindus celebrate Thaipusam to give thanks to Lord Subramaniam. This is a vibrant festival during which some

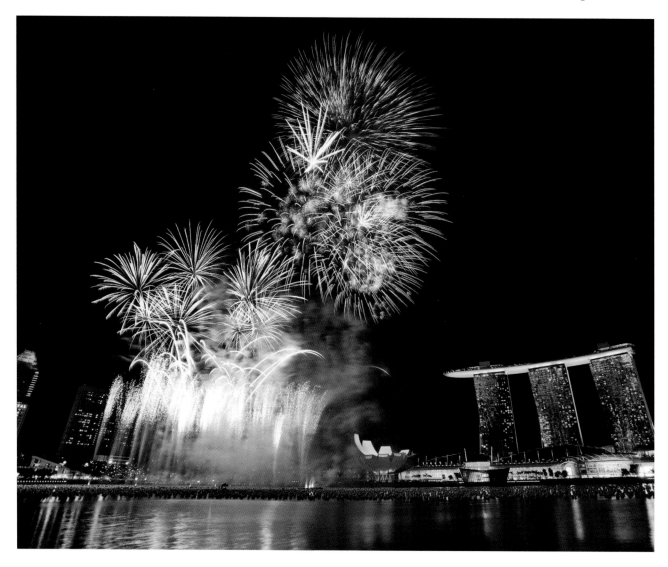

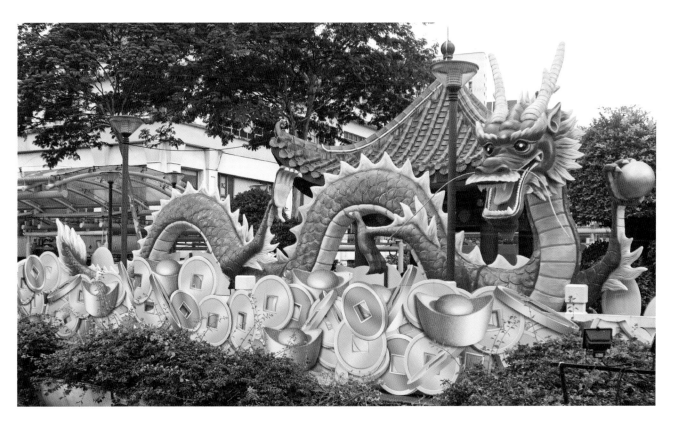

men carry heavy structures called *kavadis* in honour of their deities and as a supplement to prayer, while others attach hooks to their body or pierce it with skewers. Visitors can observe the ceremonies at Sri Perumal Temple in Little India or Sri Thandayuthapani Temple.

Some other important religious festivals include Good Friday and Christmas Day for Christians, Wesak (or Vesak) Day for Buddhists and Deepavali (Festival of Lights) for Hindus and Sikhs. Other significant festivities are the Mooncake and Lantern Festival in mid August, Festival of the Hungry Ghosts (mid August to mid September), National Day on August 9 and New Year's Day.

Left: Sri Senpaga Vinayagar Temple in Katong is a temple for the Hindu god, Ganesha.

Opposite: Fireworks often form part of festivities and events on the island.

Above: The legendary dragon is associated with Chinese New Year, one of Singapore's most celebrated festivals.

Cuisine

Multicultural Singapore offers a smorgasbord of food and dining options. Visitors can dine in celebrity chefs' signature restaurants with Michelin-star ratings or slurp a bowl of Singapore noodles in hawker centres such as Newton or Maxwell Food Centres. Rapid economic development and sophisticated local palates have seen great changes in the food offered and where it's served. Singapore is considered one of the world's most vibrant food cultures with ever-changing culinary horizons.

While it's possible to dine on food from around the world, local dishes are those that appeal most to Singaporeans as well as inquisitive visitors. Even within the three main culinary styles of Chinese, Malay and Indian there are subsets and details that render the generalization almost redundant. Singaporeans don't order *laksa* for example but rather specific styles, such as curry, *asam*, Johor, Sarawak or one of several other variations. Indian food can be northern, southern, vegetarian or Muslim Indian and Malay cuisine can include specialties originating from every Malaysian state.

While Chinese food predominates, Peranakan or Nyonya style is unique to the region. It dates back several centuries and originated from the blending of Chinese and local cooking styles. Nyonya dishes to sample include *otak otak* (minced fish barbecued in banana leaves), *ayam pongteh* (chicken, potatoes and mushrooms) plus lots of colourful *kuih* (cakes).

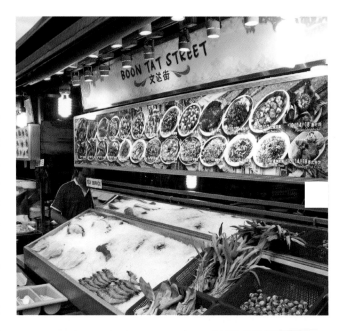

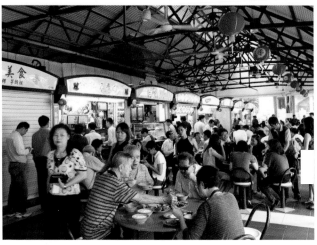

Above right: Outdoor eating areas are common and those like Makansutra Gluttons Corner, pictured, are popular in the evening.

Right: Hawker stalls like this one in Maxwell Road are where Singaporeans love to eat, especially at lunchtime as the food is always tasty and offers great value for money.

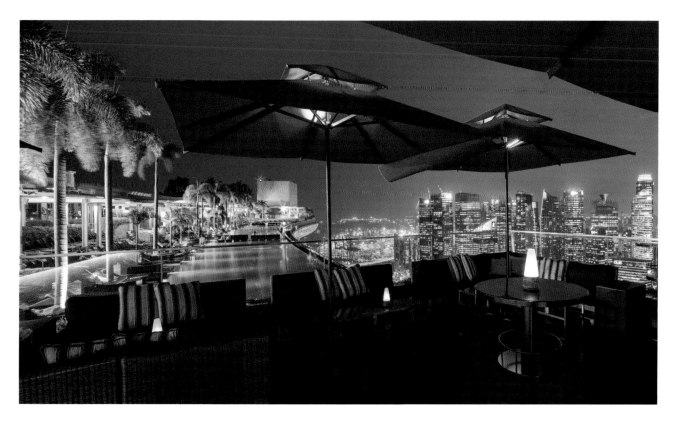

Some other classic dishes include chilli crab, black bean crab, *satay*, oyster omelette, Hainanese chicken rice and *nasi biryani* (spicy rice cooked with milk and ghee). Fruit and fruit juices are available in markets and hawkerstalls and a popular beverage is *teh tarik* (translated as 'pulled tea'). *Halal* food for Muslims is available everywhere. The local beer is Tiger and the island's most famous cocktail is the Singapore Sling developed in Raffles Hotel and best enjoyed in their Long Bar.

Above: Tea tarik or 'pulled tea' is a favourite local beverage and poured between two containers to cool it down.

Above right: Oyster omelette is a popular dish prepared in many hawkerstalls in Singapore.

Natural Habitats

Despite its high population density (estimated at 7,909 people per km^2 and the world's third highest), Singapore remains a green island. Remote imaging by the National University of Singapore shows 47% of Singapore has green cover. While green cover doesn't mean natural forests, many visitors will be pleasantly surprised by the extensive landscaping. This is in line with the government's initiative to develop a "City in a Garden".

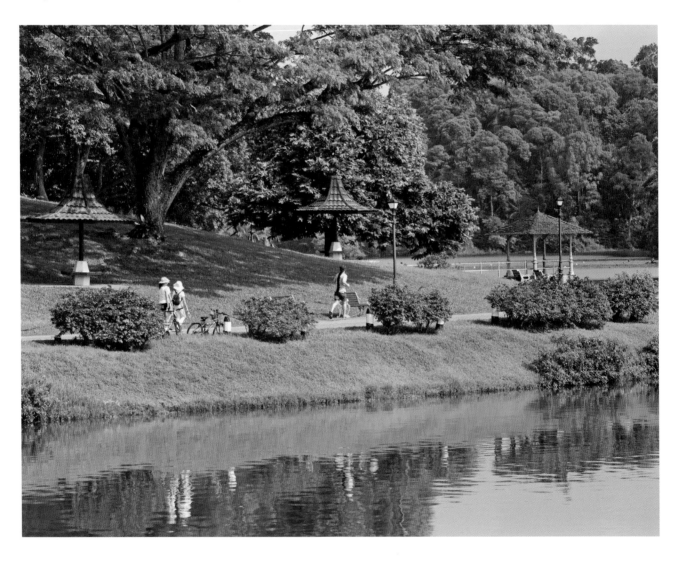

Above: *Reservoirs such as MacRitchie Reservoir are multi-purpose parks for water storage, recreation, a wildlife habitat and education.*

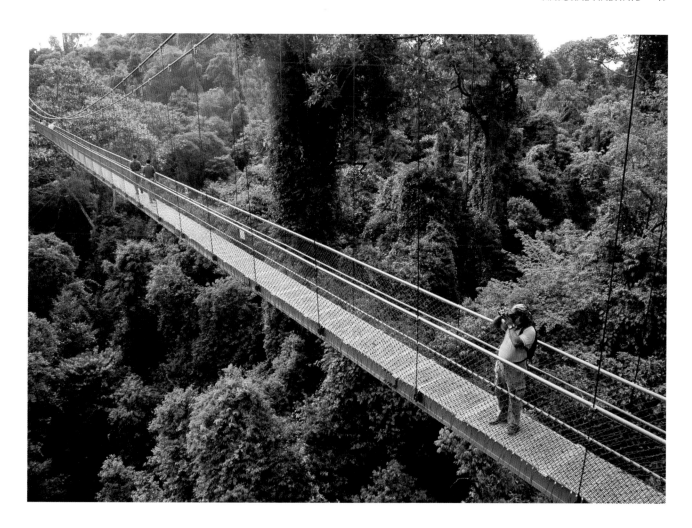

Some 10% of Singapore has been set aside for nature reserves and parks covered in lowland rainforests, freshwater swamp forests and mangrove forests. These are protected in four nature reserves – Bukit Timah Nature Reserve (see page 42), the Central Catchment Nature Reserve (see page 42), Sungei Buloh Wetland Reserve (see page 34) and Labrador Nature Reserve.

Lowland Dipterocarp Forest

Dipterocarp means "two wings" and refers to the shape of the seeds of these trees. In the early 19th century, Singapore was covered almost entirely in lowland dipterocarp forest. Botanists estimate that 82% was originally rainforest, 13% mangroves and 5% freshwater swamp forest with a small percentage of beach vegetation. Remnant pockets of these rainforests can still be found but many areas have been cleared by deforestation and land conversion; what remains is mostly secondary re-growth forest. Bukit Timah Nature Reserve is home to lowland dipterocarp forests as are the surroundings of all the water reservoirs in the area.

These forests are some of the most species-rich in the world. The bulk of the world's commercial tropical hardwoods belong to the dipterocarp tree family with species of the most common genera Shorea, Vatica and Hopea being found in Bukit Timah. While some large animals survive in forests it is often the smaller life such as spiders, insects and butterflies that are more prevalent.

Above: The Treetop Walk through MacRitchie Reservoir provides a bird's eye view of the forest.

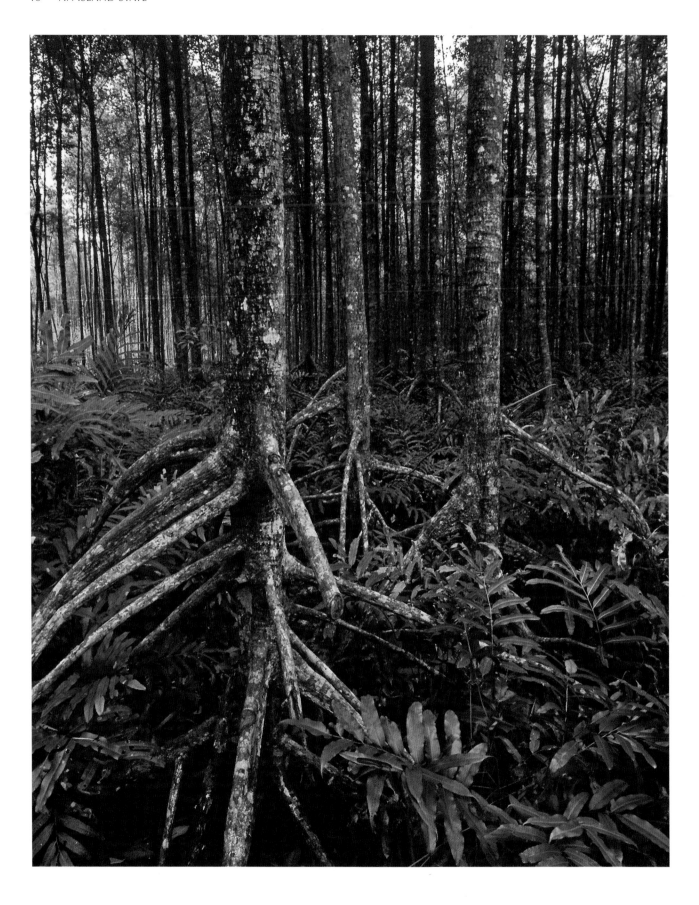

Mangrove Swamp Forests

Mangrove swamp forests line many parts of coastal Singapore. Mangroves are rich in biodiversity and not only protect the coastline from erosion and storm damage but are also important as spawning grounds for fish and crustaceans. With their distinctive aerial roots they provide a link between the land and sea and also filter out some pollutants. Crocodiles, lizards, snakes and Long-tailed Macaques inhabit mangrove forests. Smaller organisms, such as mudskippers, found here are also important to the ecosystem.

Wetlands including mangrove forests are roosting, feeding and nesting sites for waterbirds and migratory birds. Migratory birds transit through Singapore on their long journey southward from the northern winter. This is reversed months later as the birds return for the northern summer. Sungei Buloh Wetland Reserve and Labrador Nature Reserve have accessible mangrove areas for visitors to explore.

Freshwater Swamp Forest

This forest type supports a high number of freshwater species and the root systems are important for filtering the water to ensure its high quality. The 87 ha (215 acres) Nee Soon Swamp Forest in the Central Catchment Nature Reserve is Singapore's last patch of swamp forest.

Marine Environments

Being an island, the marine life in the waters surrounding Singapore is diverse and species-rich. Sea grasses occur in shallow waters like those off Changi Beach. Singapore is home to coral reefs most of which are associated with the southern outer lying islands, however urban run-off and sea turbidity means the seawater is not crystal-clear. This doesn't

stop some Singaporeans from diving off beaches and islands in the waters of the republic to see clown fish, seahorses and giant clams. A coral nursery has been established off Semakau Island and 256 out of 800 of the world's hard coral species have been recorded in Singapore waters.

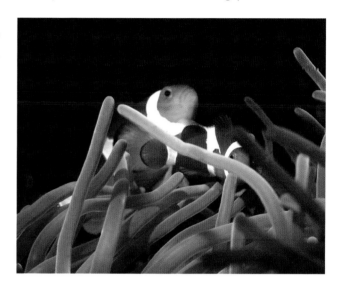

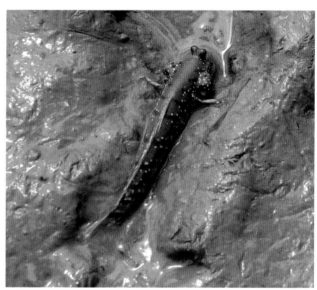

Above: Clownfish (top) inhabit the island's coral reefs while Mudskippers (below) are common in mangroves.

Opposite: Mangrove forests are an important habitat in some coastal and riverine locations on the island. The aerial roots of mangroves situated in waterlogged soils enable these plants to breathe.

Flora

Singapore's most visible plants are a mixture of wild and cultivated plants. The remnant forests are home to many unique plants that thrive under the equatorial climate. The most recent plant survey indicates that there are 4,100 vascular plant species with many surviving in the island's 300 parks. Of these, 51.3% are native plants, 43.7% exotic and 5% are weeds. The exotic plants were introduced for urban landscaping.

Below left: Mature fig trees can have a vast system of buttress roots.

Below right: Varies hues of frangipani flowers are a common sight in Singapore's parks and gardens.

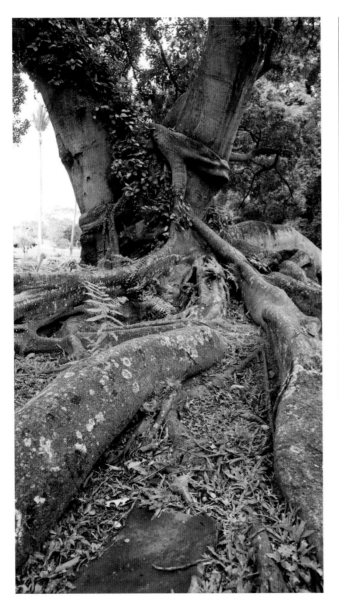

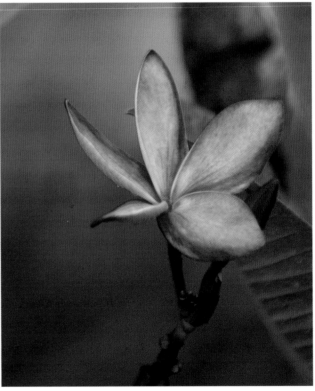

Singapore, like neighbouring Peninsular Malaysia, is part of the world's most diverse floristic region. While tree species dominate the rainforest, other plant forms such as vines, shrubs, epiphytes, orchids and non-vascular plants thrive here. Mature rainforest trees like Seraya (*Shorea curtisii*) attain a height of 80 m (262 ft) in Singapore's Bukit Timah. Large buttress roots help prevent these huge trees from toppling over.

As well as being vital for the island's ecology, there are many economically important plants. Fruit trees like durian, mangosteen and rambutan play a large part as does rattan which is used for making cane furniture. However, the most economically significant plant species in tropical Asia are introduced, such as rubber, oil palm, cocoa and coffee.

Singapore's equatorial climate ensures a profusion of colourful flowers, such as frangipani, lilies and lotus in forests, waterways, gardens and parks. Within the rainforest, visitors can also see gingers, ferns, palms and plants ranging in colour, shape, size and function. Various forest trails through nature reserves and parks enable closer observation of the island's complex flora.

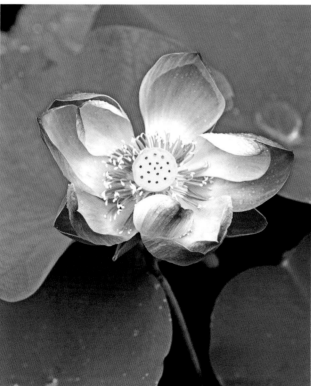

Above: Visitors can access many parks via a series of well-maintained trails.

Top left: Large, glossy leaves are common in the rainforest.

Below left: The beautiful lotus flower grows in ponds, wetlands and riverbanks.

Fauna

Singapore's greenery provides various habitats for a range of fauna. While large mammals only survive in the Singapore Zoological Gardens, there are many smaller mammals, reptiles, butterflies, insects and amphibians in the natural environment. A total of 403 bird species have been identified on Singapore as well as 300 butterfly species.

Visitors to Sungei Buloh Wetland Reserve may see wild crocodiles up to 2 m (6.5 ft) long on the banks of the muddy estuaries. Of the 65 mammals recorded in Singapore, the two largest mammals are marine – the Dugong (*Dugong dugon*) and dolphins. On the land, the largest mammal is the Wild Pig (*Sus scrofa*). Other large animals living in the forests include primates such as the Long-tailed Macaque (*Macaca fascicularis* or Crab-eating Macaque) and the Banded Leaf Monkey (*Presbytis femoralis femoralis*). The Plantain Squirrel (*Callosciurus notatus*) is one of the most common small mammals and, in parts, the Colugo (*Galeopterus variegatus*) thrives.

The Long-tailed Macaque is the most common of the primates especially around the forest fringes of the Central Catchment Area. Surveys suggest that while they appear common in some areas, there are only about 70 troops, or less than 1,500 individuals in Singapore. They are social animals that live in groups of 15 to 30 individuals with a dominant alpha male. They feed on forest leaves, shoots, flowers and fruits.

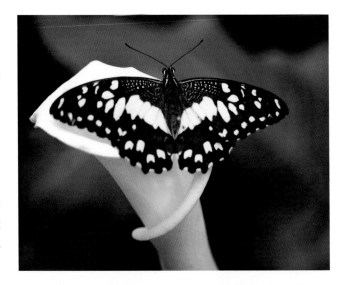

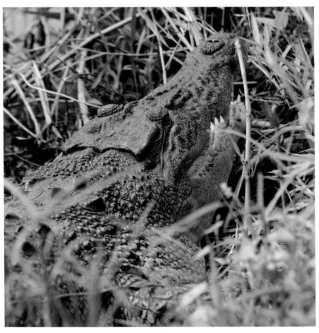

Above right: *Butterflies are commonly found all over the island.*

Right: *The critically endangered Estuarine or Saltwater Crocodile is best seen in Sungei Buloh Wetland Reserve.*

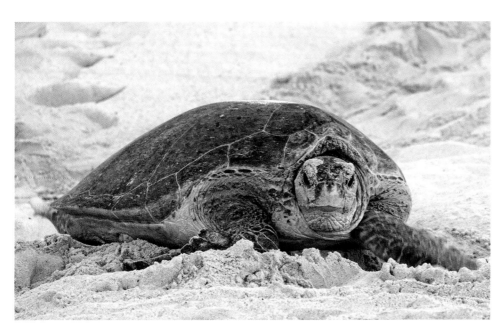

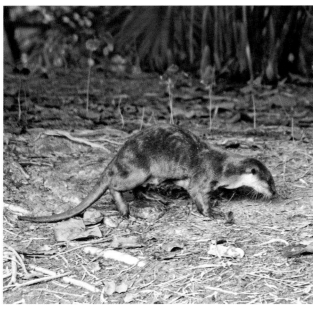

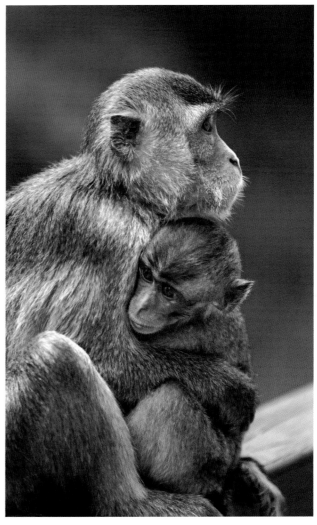

Left: Turtles live in the waters surrounding Singapore and occasionally lay their eggs on sandy beaches, especially in the southern islands.

Below left: Otters can be seen at Sungei Buloh.

Below right: Long-tailed Macaques are the most commonly seen monkey in Singapore.

While Singapore is one of the most urbanized places on Earth, expansive natural areas remain with vegetated corridors connecting some to enable wildlife to move about freely. There are currently 24 Nature Areas including the Central Catchment Nature Reserve (3,043 ha/7,519 acres) and Bukit Timah Nature Reserve (163 ha/403 acres). All reserves provide valuable habitats for fauna and flora and make a valuable contribution to Singapore retaining its biodiversity.

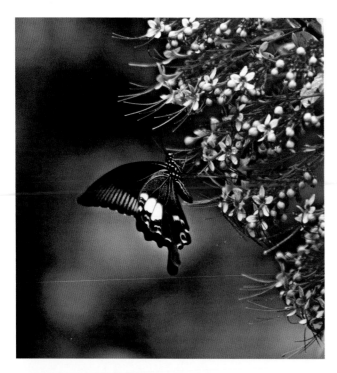

Smaller fauna include insects, bats, otters, rodents, reptiles, spiders, amphibians and butterflies. Some insects live in colonies and play an important role in breaking down forest detritus into soil. The Reticulated Python of South-East Asia (*Python reticulates*) is typical of many reptiles in being well camouflaged. It can grow to almost 10 m (33 ft) making it the world's largest snake that is reputed to digest large animals (typically, mature pythons are only half this size). It can be found in all forest types and urban areas.

Left: *Abundant landscaping throughout Singapore attracts some 300 butterfly species.*

Below: *Damselflies can be spotted around the reeds and plants found in wetlands around the island.*

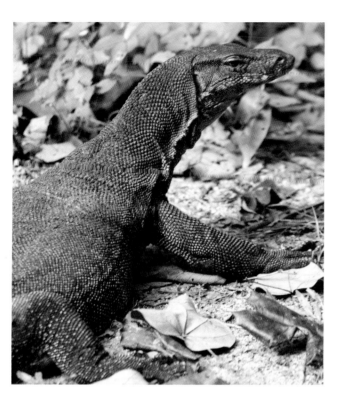

A more commonly seen reptile is the Malayan Water Monitor (*Varanus salvator*) which frequents rivers, mangroves and coasts. Despite an average size of 1.5 m (5 ft) it can move swiftly across the land and is a good swimmer. It is a carnivore and eats frogs, fish, rodents, crabs and snakes. There are many other reptiles and amphibians recorded including turtles and lizards.

Birds are another important part of Singapore's faunal inventory and are commonly sighted in urbanized areas. The three mostly commonly seen birds are the Javan Myna (*Acridotheres javanicus*), House Crow (*Corvus splendens*) and Asian Glossy Starling (*Aplonis panayensis*). Interestingly, the first two are introduced species.

Left: Water Monitor lizards live on the land but are equally as agile in water.

Below: Water Monitors eat a wide variety of animals from the land and the water.

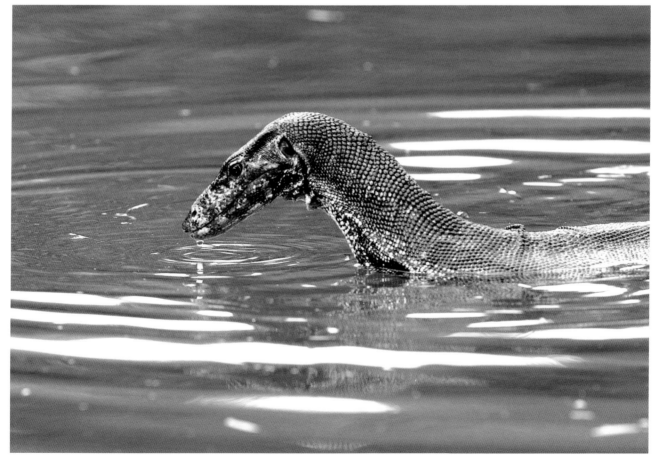

Land and Resources

Land and water are precious commodities in Singapore. Singapore is possibly the world's most urbanized country with 100% of the population classified as living in urban areas. Urban planning is important to ensure that current and future generations maintain their high living standard.

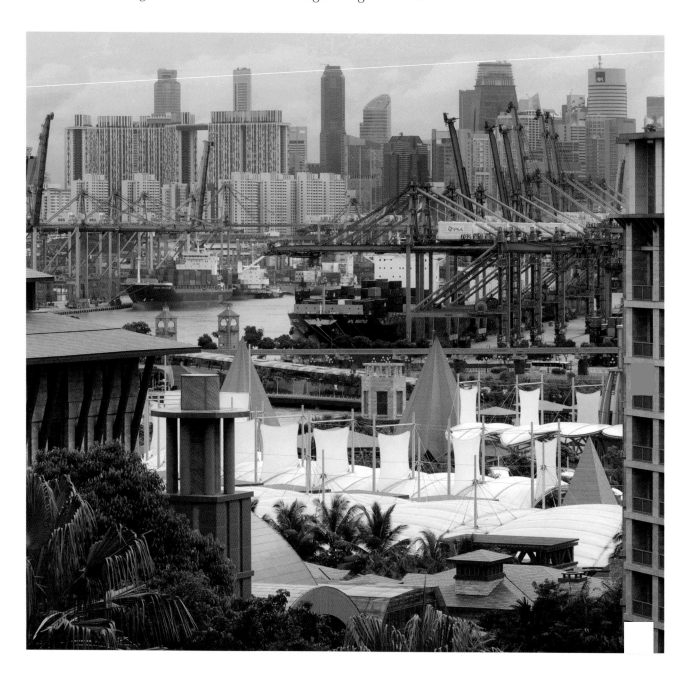

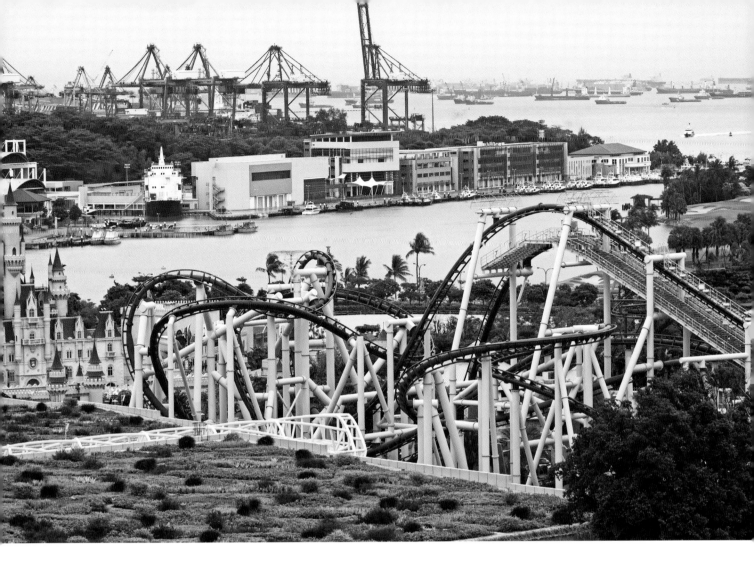

No natural resources are mined and agriculture only contributes a small contribution to Singapore's Gross Domestic Product (GDP), so it is imports and exports and the service industry that have turned a near-deserted island into one of the world's most prosperous nations. Singapore has an open business environment, low tax rates and one of the highest per capita GDPs in the world. The government is pro foreign investment and its economy is one of the fastest growing in the world.

One of the common statements about Singapore is that it works. It does this because of political stability and initiatives to develop a safe, healthy and educated society. Business drives these social initiatives with the Singapore economy having transformed from trade to manufacturing, the service sector and high technologies. This was facilitated by advances in the financial and communications industries.

Manufacturing, chemicals, petroleum, finance and tourism are important sectors of the export-oriented economy. Singapore's major trading partners are Malaysia, Indonesia, Hong Kong, the European Union, China, the United States and Japan. The country is also rated very highly for the ease of business relationships.

Opposite: There is always a flotilla of ships moored offshore waiting to load or unload goods from around the globe. The Tanjong Pagar port and its mountain of containers is an indicator of the importance of trade to Singapore.

Above: Tourism is very important to the Singapore economy: the two integrated resorts and theme parks, such as Universal Studios, have stimulated the tourism sector.

Sports and Lifestyle

Quality of life is something that is important to most Singaporeans. There are many facilities and services to ensure that its residents and all those who visit enjoy the good things on offer. An extensive range of sports, events and recreational activities make this a very livable island nation.

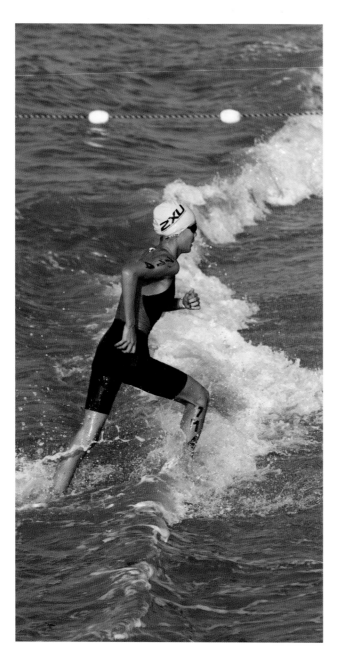

Singapore staged its first F1 Grand Prix motor race in September 2008 and it is now one of the most prestigious races on the F1 calendar. The event was the first night race staged and it takes place on a street circuit of five kilometres (just over three miles) with a floodlit track around Marina Bay. Entertainment activities extend over several days either side of the race and visitors who come outside the actual race can see the pit area and spectator facilities which are permanent fixtures.

Being an island, watersports are popular with several beaches located on Sentosa Island (see page 74). Sailing is well-established with several marinas and competitive races for Optimist and Laser classes among others. Kayaking on one of several lakes like Bedok Reservoir is well patronized and triathlons are becoming increasingly popular for participants of all ages.

For such a small island, golfers are well catered for with 21 courses ranging from public ones to members-only. Despite the number, this is not enough to meet the growing demand for the sport and many golfers choose to play in Malaysia.

Left: Being an island, watersports are important recreational activities in Singapore and events such as triathlons involving international athletes are regularly staged.

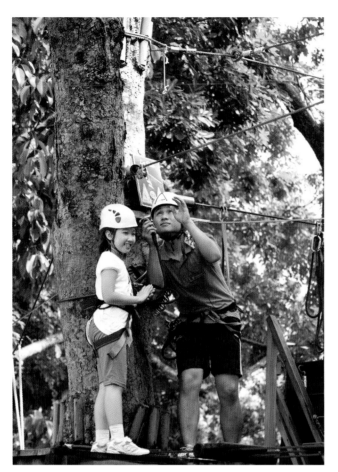

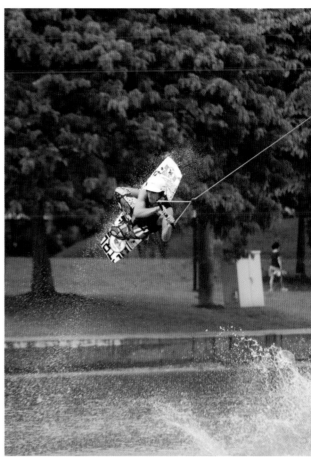

Above left: Action adventures in forested areas such as those offered at Forest Adventure are available for all ages.

Above right: Enjoy the excitement of wakeboarding at Singapore Wakeboard Park.

Left: Golf is a popular sport for upwardly mobile Singaporeans with some 21 courses from which to choose. Most include lush and mature landscaping and offer golfers the opportunity to enjoy the island's warm tropical climate.

Cricket and rugby are well established especially on the central Padang. The East Coast Parkway is 17 km (10½ miles) long and covers 185 ha (457 acres). Extensive trails enable cycling, jogging and inline-skating while the area is popular for fishing, kite-flying, dining and recreation. Ski 360° is located here and offers cable-skiing and wakeboarding. People also hike through Singapore's many parks and along well-established trails within nature reserves administered by Singapore's National Parks Board. Passive recreational activities, such as bird watching, photography and art, have dedicated followers.

Parkland forests around Bedok Reservoir are the base for Forest Adventure, an aerial rope course involving ladders, bridges, trapezes and a 200-m (656-ft) long zip line across water. A smaller kids' course enables people of all ages to enjoy the adventure.

Shopping is an important pastime for both locals and visitors – it has even been suggested that Singapore is the "world's only shopping mall with a seat in the United Nations." The Great Singapore Sale extending from late May to late July is the best time to visit as the whole island goes on sale. The premium shopping area is Orchard Road but there many areas where shopping malls dominate the landscape. Western-styled malls with international designer brands feature along Orchard Road but in Chinatown and Little India more traditional Asian forms of shopping are the norm. Bargaining is expected in many locations but prices are fixed in department stores. Singapore has a Goods and Services Tax (or VAT) of 7% which foreigners can claim back upon departure from Changi Airport.

Hotels play a big role in Singapore life with restaurants being well patronized and many offering Sunday brunches, lavish buffets and inviting bars. In addition to international brands several local names dominate the hotel scene. There are also a number of iconic bars that are popular with locals and tourists.

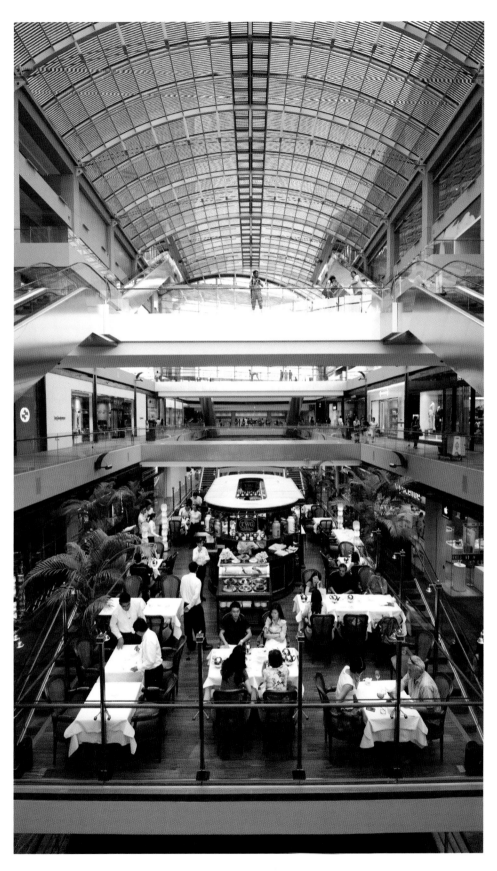

Left: There are many great places and endless opportunities for shopping in Singapore. For come, shopping is the most important function of a holiday and Singapore is well equipped to cater to such travellers. While traditional shops and markets exist, most developers strive to construct the latest, best-equipped and air-conditioned shopping malls offering stores, restaurants, cinemas and often adjoining hotels. Pictured is 'The Shoppes' complex, part of Marina Bay Sands.

Opposite: With 403 recorded bird species in Singapore, natural areas such as Sungei Buloh Wetland Reserve in the far north-west of the island are excellent locations for sighting wetland species. Good interpretation signs are helpful for novice birdwatchers and informative guides offer free guided weekend walks. During the bird migratory season from September to March birds from the north migrate to warmer climates in the south and then back as the north enters summer — they use the reserve as a resting place on their way through.

Chapter 2: Natural Paradise

Despite being a densely populated island, concerted efforts have been made to ensure Singapore develops into a "City in a Garden". Parks and protected natural areas ensure a home for flora and fauna as well as areas for people to enjoy as recreational space.

Singapore Botanic Gardens

Singapore Botanic Gardens are centrally located just beyond the western extremity of the Orchard Road retail and commercial area. The 64-ha (160-acre) gardens date back over 150 years and are valuable for research, scientific experimentation, conservation, education and recreation.

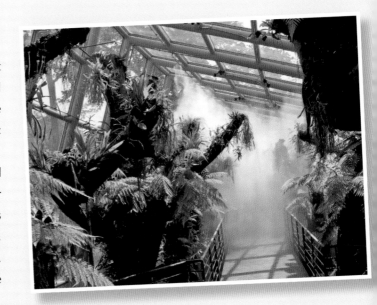

What started out as an ornamental garden has developed into one of the world's leading botanic gardens. Rubber seedlings were first grown here in 1877. These early plantings contributed to one of Asia's most valuable cash crops. Palms, cycads, gingers and bromeliads are also well represented. The Singapore Botanic Gardens were inscribed on the prestigious UNESCO World Heritage Sites List in 2015.

Above right: Colourful orchids and lush tropical foliage are a feature of the Tan Hoon Siang Mist House.

Right: Many residents and visitors spend time in the Botanic Gardens relaxing, walking or even practising 'tai chi' and there are various facilities from a Visitors' Centre, restaurant, children's garden and shop.

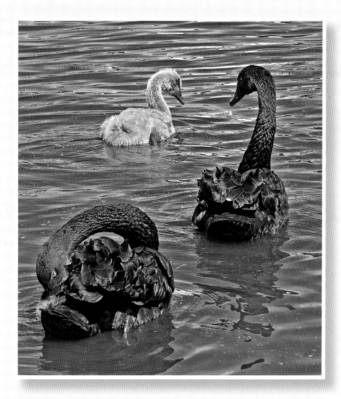

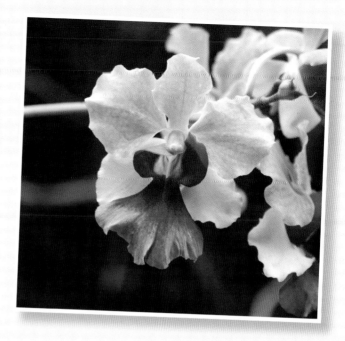

Above: Swan Lake with its resident flock of Black Swans is also a good place to rest.

Above: Visitors can admire Singapore's national flower, the Vanda Miss Joaquim in the National Orchid Garden which covers 3 ha (7.5 acres) and contains over 60,000 specimens from 1,000 species. This is considered the world's largest collection of tropical orchids and 2,000 hybrids have been developed here.

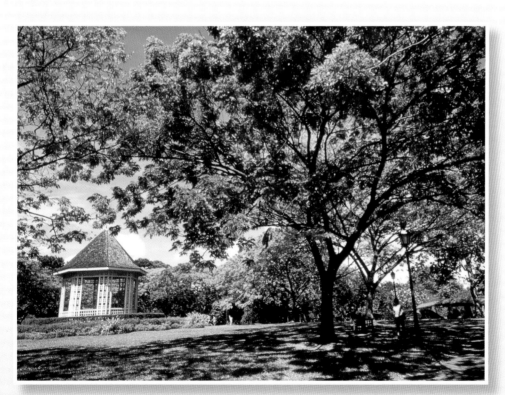

Left: The Tanglin Core area has historic structures, such as a bandstand, sculptures and heritage trees. The octagonal bandstand dates back to when band music was played here for those promenading through the gardens.

Sungei Buloh Wetland Reserve

It's hard to imagine that there are estuarine crocodiles inhabiting the Singapore foreshores yet Sungei Buloh Wetland Reserve in the island's northwest is home to crocodiles as well as waterbirds, marine organisms and specialized plants that can survive in the brackish waters of mangrove forests. Over 230 bird species have been recorded here of which 50% are residents.

This 130-ha (321-acre) site covered in mangroves, mudflats, ponds and secondary forest has been a protected reserve since 2002 and is Singapore's first ASEAN Heritage Park. It plays an important role in conservation and research as well as providing wonderful opportunities for natural encounters through guided walks and the provision of hides for those seeking something different.

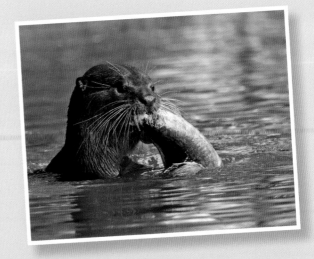

Above and below: Several shaded areas are ideal places to sit quietly to watch for animal life, such as Smooth Otters which can be seen hunting for fish.

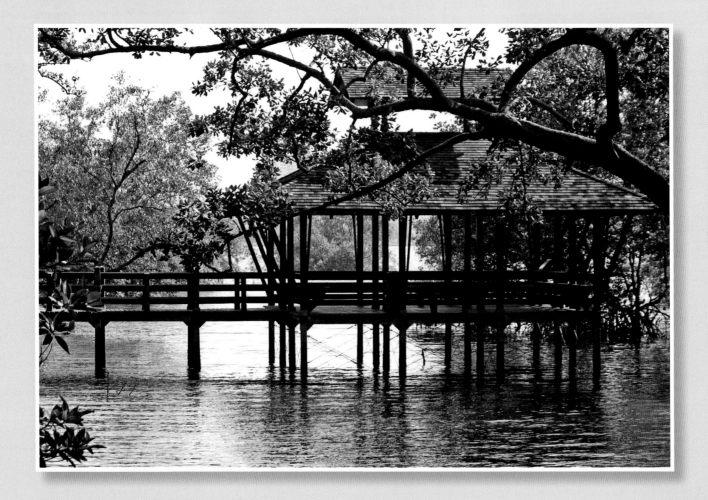

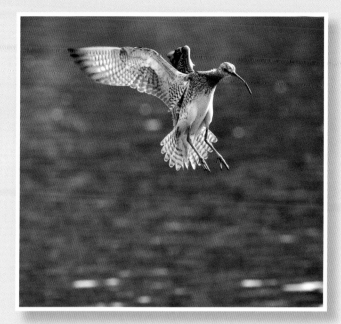

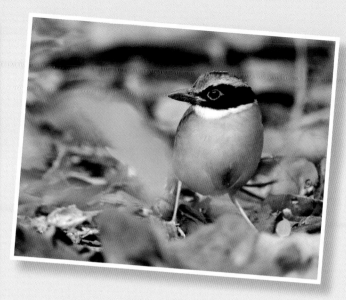

Above: The Blue-winged Pitta is a winter visitor and passage migrant to Singapore.

Below: The Common Moorhen is a resident of lakes and freshwater marshes.

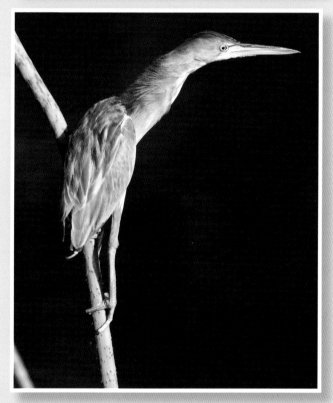

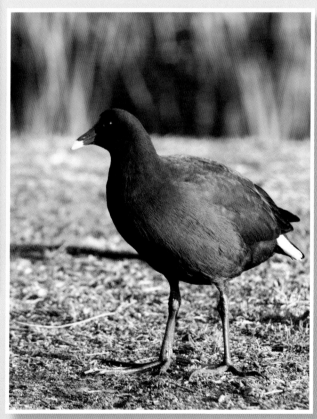

Top: The Whimbrel is a wader bird that feeds on small invertebrates and crabs that live on mudflats.

Above: The Chestnut Bittern is usuallly seen amongst the reeds lining the Sungei Buloh wetlands.

Singapore Zoological Gardens and Safaris

Singapore Zoo covers 28 ha (69 acres) and includes 3,000 animals representing 400 species from most continents with an emphasis on the tropics. Visitors can see animals such as deer, Hyenas, Giraffes, Malayan Tigers, Leopards, Tapirs and Asian Elephants. The world's first Night Safari here offers a unique experience for visitors to see nocturnal animals in the dim evening light. Equally ambitious is the new River Safari where visitors take boat rides in a freshwater 'aquarium'. One of the main attractions is a pair of Giant Pandas, housed in a special, climate controlled enclosure.

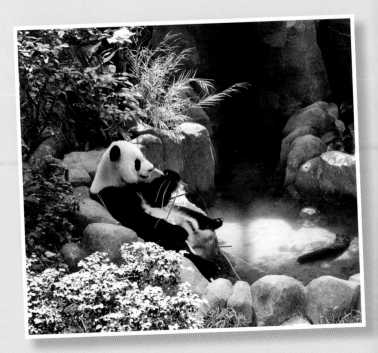

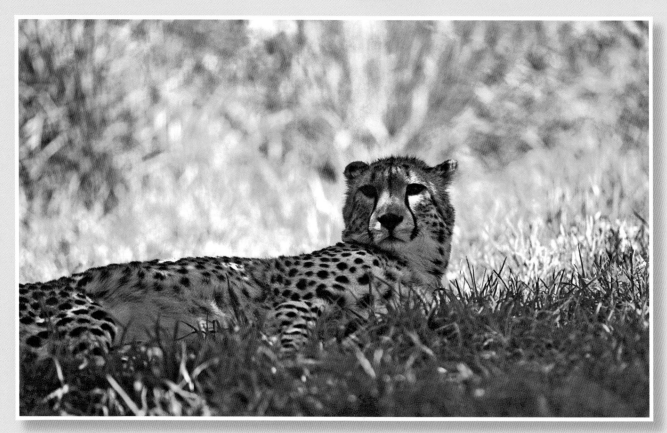

Above: Singapore Zoo has a section on African animals including the Cheetah, the world's fastest land mammal.

Top: The male panda, Kai Kai, can be seen during the River Safari.

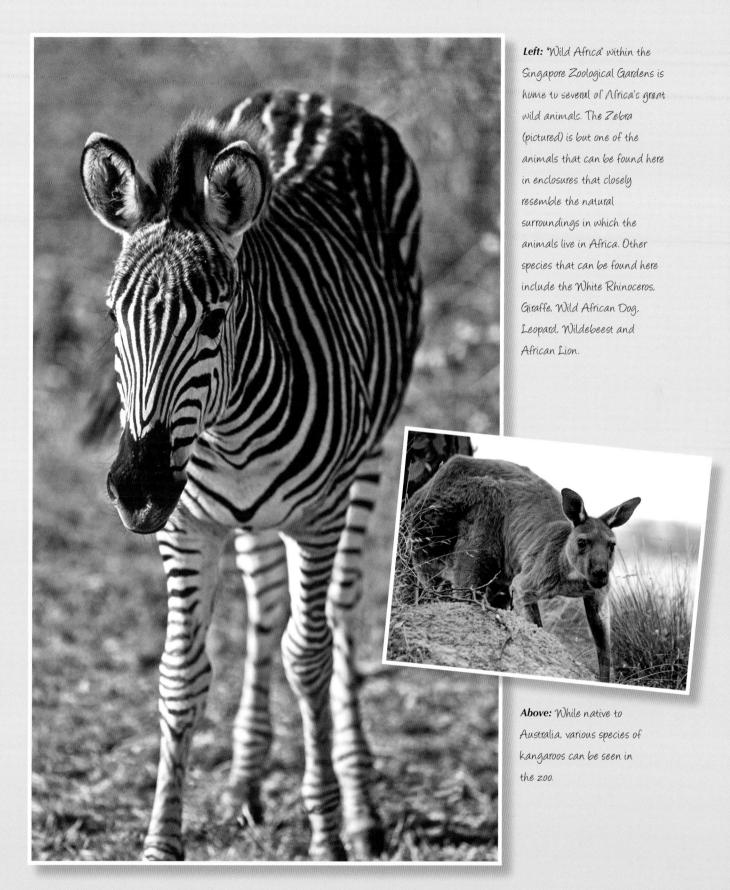

Left: "Wild Africa" within the Singapore Zoological Gardens is home to several of Africa's great wild animals. The Zebra (pictured) is but one of the animals that can be found here in enclosures that closely resemble the natural surroundings in which the animals live in Africa. Other species that can be found here include the White Rhinoceros, Giraffe, Wild African Dog, Leopard, Wildebeest and African Lion.

Above: While native to Australia, various species of kangaroos can be seen in the zoo.

Underwater World Singapore

Both Underwater World and Dolphin Lagoon on Sentosa Island offer visitors an opportunity to get closer to some of the marine life that thrives in Singaporean waters. The biggest attraction is the 83-m (272-ft) clear tunnel in Underwater World which gives people the impression that they are walking through the sea with 250 tropical marine species swimming around them.

There are other displays here where lesser seen organisms, such as sea dragons, puffer fish and jelly fish, can be observed. Hands-on, touch pools enable children to get close to some of the aquarium's residents.

Dolphin Lagoon is included in the entry price and here Pink Dolphins and seals put on an orchestrated display five times daily.

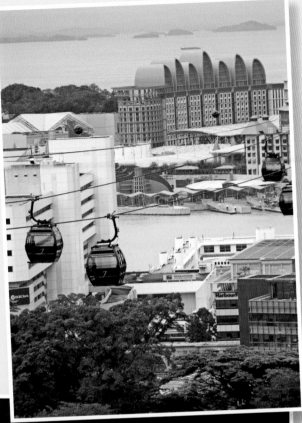

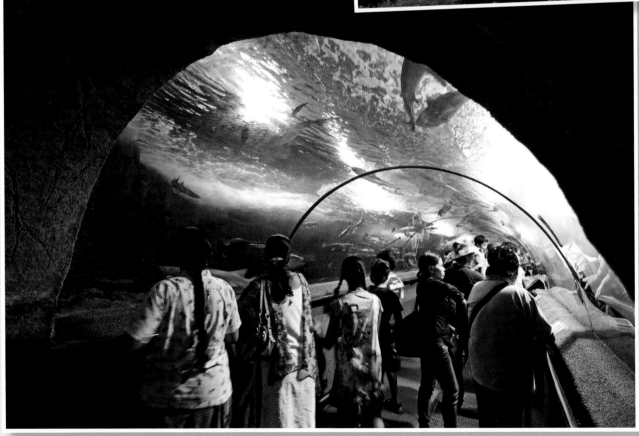

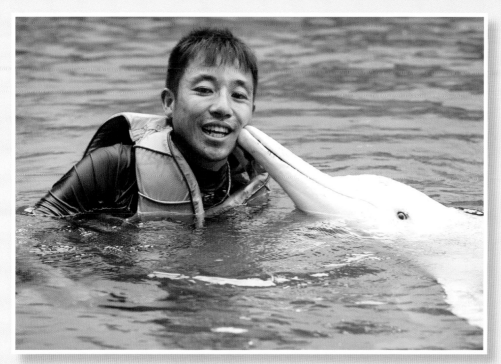

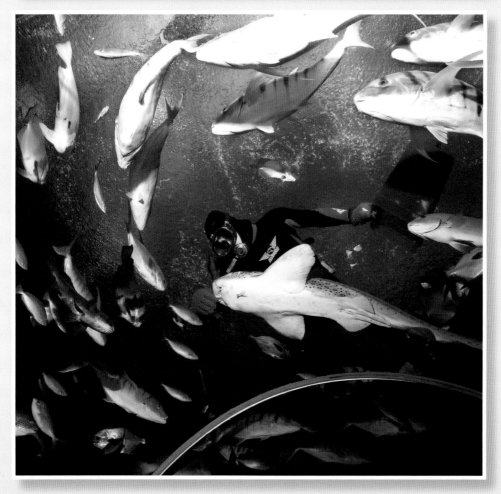

Left: In Dolphin Lagoon visitors can gear up in the equipment provided and get into the tanks for activities such as 'Dive with the Sharks' or 'Swim with the Dolphins'.

Below: Staff in scuba gear are often in the tank to offer a sense of scale to the large sharks.

Opposite above: The cable car from Mount Faber on the main island takes visitors to Sentosa Island where Underwater World is located.

Opposite below: A conveyor carries visitors through the transparent acrylic tube. As they progress, 2,500 organisms including sharks, massive eels, shoals of fish and rays swim past, providing close encounters with creatures not normally seen.

Jurong Bird Park

Opened in 1971, Jurong Bird Park is the world's largest bird park, offering a 20.2-ha (50-acre) haven for 5,000 birds representing 400 species. Its Heliconia Repository, with 108 heliconia flower species and cultivars, is one of the region's largest. With attractions such as the Bird Discovery Centre, African Waterfall Aviary, Lory Loft Aviary, South-East Asian Birds Aviary and Penguin Coast, the park is popular with tourists and locals. Children can attend classes and dedicated tours with informative guides are available. There are opportunities to get close to the birds during feeding sessions. From an underwater viewing area at Pelican Cove, visitors can see seven species feeding.

Committed to conservation, the park is the first in the world to breed the Twelve-wired Bird of Paradise in captivity. It has a Breeding and Research Centre tasked to ensure the welfare, breeding and promulgation of birdlife and there is also a designated rescued avian centre. The park is part of Wildlife Reserves Singapore and is the only Asia-Pacific region park to have a fully-equipped avian hospital.

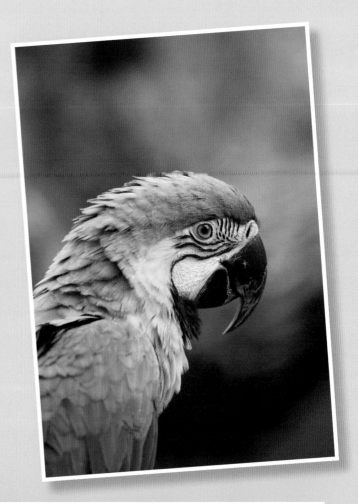

Above: One of the most colourful species in the park is the Blue and Gold Macaw, a parrot that is native to the rainforests of Central and South America.

Right: Flamingos are some of the world's most beautiful tall birds and are commonly seen standing on one leg.

Opposite: Birds such as Superb Starlings (Lamprotornis superbus) can be seen feeding in parts of the park including this cool waterfall oasis.

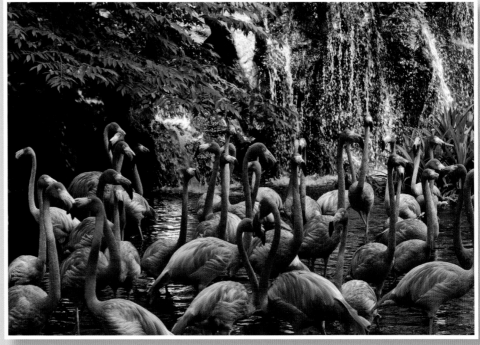

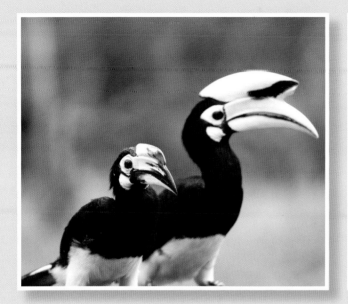

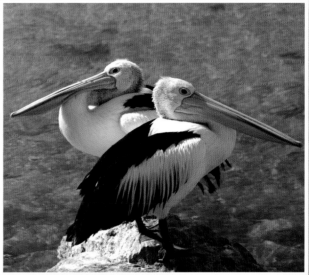

Above: Oriental Pied Hornbills are native to the tropical rainforests of the region.

Above: Pelicans are large waterbirds with a voluminous throat pouch and long beak that they use for catching fish.

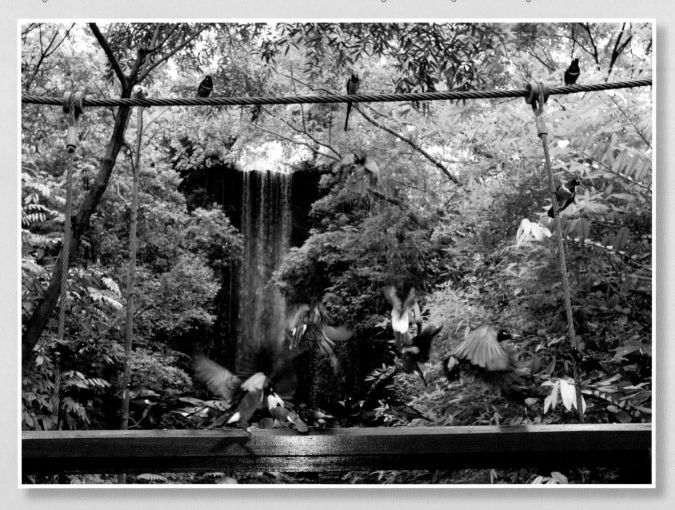

Bukit Timah Nature Reserve

This nature reserve forms part of the Central Catchment Area which includes the Upper Seletar, Upper Peirce, Lower Peirce and MacRitchie Reservoirs covering 3,043 ha (7,519 acres). The reservoirs play a major role in capturing rainwater which is a valuable resource in Singapore.

This 163 ha (403 acre) reserve was established in 1883 to protect forests, the wildlife and the catchment area. Within it is Singapore's only substantial remaining primary rainforest as well as Bukit Timah (or Timah Hill), Singapore's highest point at 164 m (538 ft). Some 850 flowering plants and 500 animal species have been recorded in Bukit Timah.

The rainforests here have several layers including emergents which rise above the canopy as well as a distinctive understorey. A variety of flowers such as ginger and the Black Lily (*Tacca integrifolia*) survive in the understorey. Thick woody vines (lianas) are common as are buttress roots. Epiphytic ferns such as Bird's Nest Ferns grow on the trunks and larger branches. A walk along the 250-m (820-ft) long TreeTop Walk from Bukit Peirce to Bukit Kalang in MacRitchie provides a canopy perspective 35 m (115 ft) above the ground.

Long-tailed Macaques, Common Treeshrew, Colugo (or Flying Lemur) and the ant-eater called Pangolin live in the forest. Reptiles including the Clouded Monitor Lizard are common around water. Forest birds such as the Greater Racket-tailed Drongo, Asian Fairy Bluebird and Crimson Sunbird are common.

Right: Some trees in the tropical rainforest grow to a height of 40 m (151 ft). The understorey of tropical rainforests has reduced light due to the density of the canopy cover and immature trees must grow quickly in order to attain more sunlight. Large trees develop buttress roots to support the sheer weight and size of the tree. The climatic conditions of the rainforest are so luxuriant that many types of plants live here with lichens thriving on the bark.

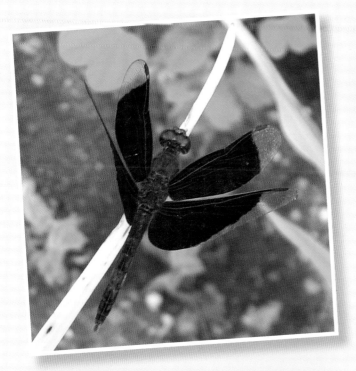

Left: Animals are well camouflaged and often difficult to see in the rainforest but there is a myriad of insects such as colourful dragonflies.

Above: Epiphytes that derive nutrients and water from the air are commonly seen on rainforest tree trunks and branches.

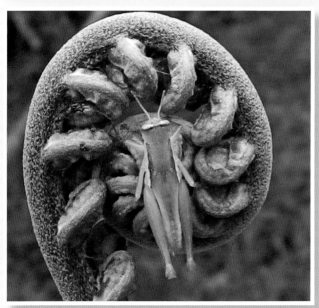

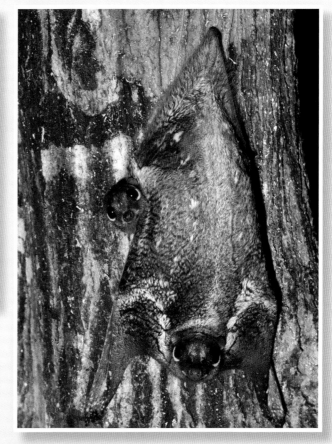

Above: Bukit Timah is home to grasshoppers and unusual plants like this unopened fern.

Right: The Colugo or Flying Lemur is a tree dwelling mammal that uses a flap of skin between its legs to glide through the rainforest.

Chapter 3: Cultural Attractions

Singapore's fascinating multicultural society is reflected in the island's eclectic architecture, places of worship, food outlets and almost every other facet of life. While distinctly Asian it is also one of the region's most Westernized cities enabling visitors to experience the best of the East and the West.

Empress Place

This area is also known as the colonial district with its centerpiece, the grassy Padang which has been used for sporting events since the 19th century. Cricket and rugby have been played here since the 1830s and it has been home to the members' only Singapore Cricket Club since 1852.

Surrounding the Padang are grand colonial buildings such as the old Supreme Court, City Hall and St Andrews Anglican Cathedral. Just behind the Cricket Club towards the Singapore River are other stately buildings such as the Victoria Theatre and Concert Hall, Old Parliament House and the Asian Civilizations Museum. Singapore's old Supreme Court Building is topped by a copper dome and features impressive Ionic columns. The National Art Gallery of Singapore is located in the former Supreme Court and City Hall buildings.

Raffles Landing Place and the Asian Civilizations Museum are nearby. The former is represented by a statue of Raffles and marks where Raffles landed on January 29, 1819. The museum located in the Empress Place Building traces the history of various Asian cultures.

Above: Guests of the Singapore Cricket Club can immerse themselves in the colonial ambience of bars and lounges such as the Men's Bar (where women are now welcome), Stumps and The Oval.

Opposite: Built in 1827, Old Parliament House is Singapore's oldest surviving government building which served as a courthouse before being the Parliament House from 1962 to 1999. It is now home to The Arts House for contemporary art and performances. Singapore's parliament now operates within the new Parliament Building located immediately next door.

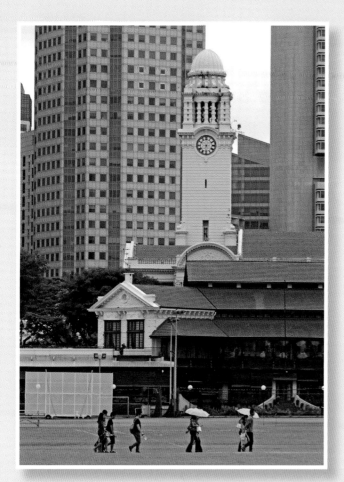

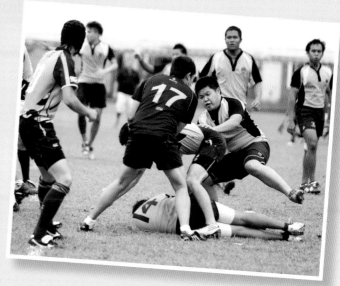

Left: Victoria Theatre and Concert Hall was built in 1862 and originally served as the Town Hall; the concert hall was added in 1905. Now a live music venue, its distinctive clock tower rises tall over the Padang.

Above: The Padang is home to a cricket ground as well as several rugby pitches where teams mostly compete in the cool of the afternoon.

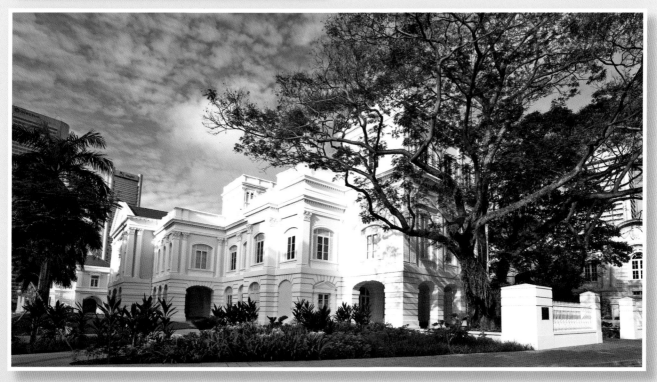

Fort Canning

Situated near the Orchard Road shopping precinct, Fort Canning provides recreational parklands covered in trees such as figs, the Cotton Tree, Yellow Flame Tree and Rain Trees. Birds, squirrels, bats and reptiles inhabit the park. A water reservoir that was once a natural spring occupies about 25% of the park's total area of 18 ha (44.5 acres).

Outdoor concerts are staged on Fort Canning Green situated in front of the Fort Canning Centre which is home to a performing arts company.

It is the most historical part of Singapore having been the centre of an ancient kingdom called Temasek dating back to the 14th century. There is an archaeological dig site and the Hotel Fort Canning has archaeological remains in its lobby.

The hill became a fort in 1860, named after Viscount Canning, Governor General and first Viceroy of India. Its function as a military base remained until the 1970s firstly for the British, then for occupying Japanese forces and Singaporean soldiers.

The Battle Box was an underground bomb-proof bunker serving as Britain's Headquarters for the Malaya Command at the beginning of World War II. It is the site where General Percival decided to surrender to invading Japanese forces on February 15, 1942. The entrance to the Battle Box is near the historic Hotel Fort Canning.

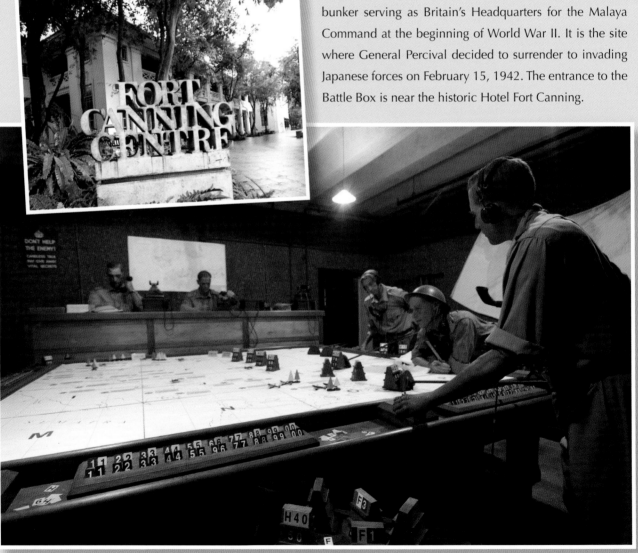

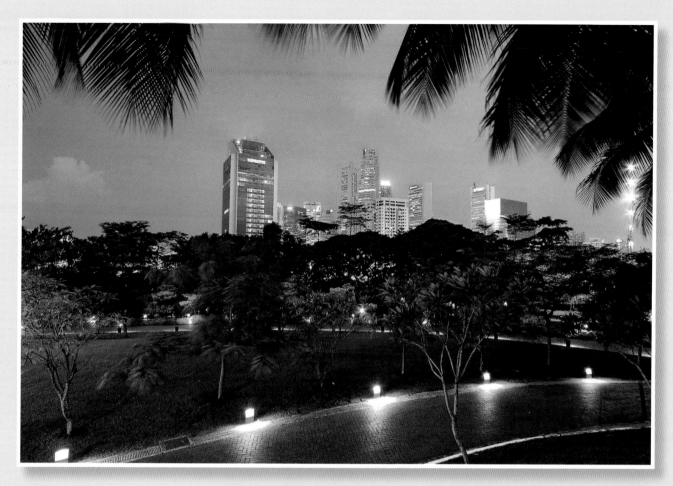

Above: Fort Canning's elevated position makes it a good vantage point for views over the Singapore River (above). This fact was not lost on Sir Stamford Raffles who built a bungalow and botanical garden here in 1822. The Spice Garden is now located on this site and there are remains of the old cemetery walls and Fort Gate (right).

Opposite: Now a war museum, the Battle Box faithfully recreates the wartime tension.

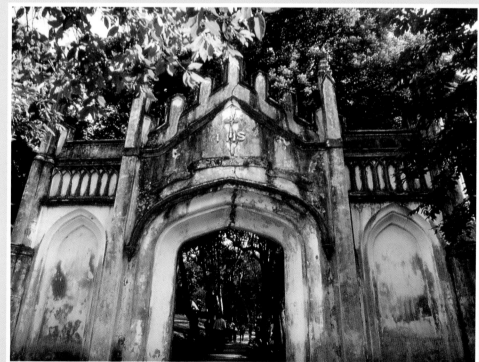

Heritage Hotels

Several historic buildings have been converted to hotels. One of these, Raffles Hotel, is a tourist destination in its own right. While renovated to incorporate contemporary fixtures several times with the most recent in 2019, most sections of the National Monument are as they were when it was built in 1887. Parts of this deluxe hotel are open to the public but others remain the exclusive domain of in-house guests. Built by the Sarkies Brothers from Armenia it was a member of an exclusive collection of properties that included Penang's Eastern & Oriental Hotel and The Strand in Yangon (Rangoon). The hotel museum is full of interesting memorabilia while bars and restaurants are popular with visitors if only to enjoy the famous Singapore Sling cocktail.

Renovations of other historic buildings have seen hotels such as the New Majestic, Wanderlust, Scarlet, The Club and Hotel 1929 opened as boutique hotels.

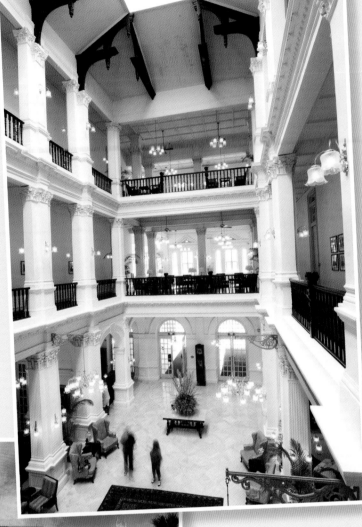

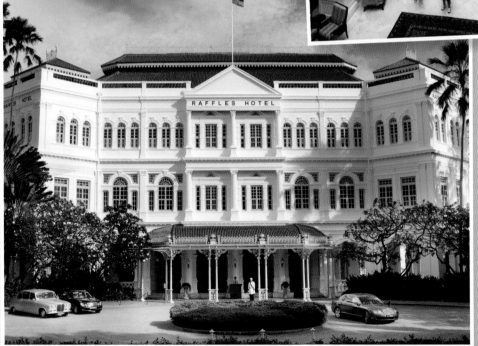

This page: Raffles Hotel opened on Beach Road in 1887 with just ten rooms and beautiful sea views from the front entrance (below). Additions were made not long after and the hotel quickly became one of the most fashionable properties in the region. Today, the elegant and graceful lobby (above) remains the domain of discerning international travellers.

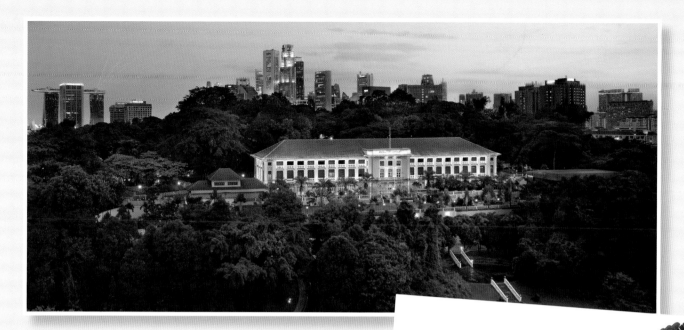

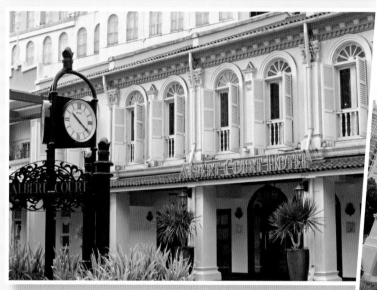

Top: Hotel Fort Canning is located in a building originally built by the British in the 1920s and used by the British Far East Command prior to their surrender in 1942. After the war, it was used as a training college by Singapore's Armed Forces. It is now a private club and 86-room boutique hotel.

Above left: Double-storey, pre World War II houses were once common in the centre of Singapore; some have been restored and reopened as trendy restaurants, bars, cafés and hotels. Village Hotel Albert Court (pictured), retains its historic facade but incorporates many modern features.

Above right: Goodwood Park Hotel is a luxurious heritage property built in 1900 as the Teutonia Club, an elite enclave for expatriate Germans. Under new management it became a hotel in 1929 and, like the Raffles Hotel, it is a National Monument. This deluxe hotel located on Scotts Road was also the first hotel in Singapore to offer its guests a swimming pool.

Museums and Galleries

There are several excellent museums including the Asian Civilizations Museum (see page 44), National Museum of Singapore and Peranakan Museum while the Singapore Art Museum (SAM) is the nation's leading art gallery.

The National Museum of Singapore (formerly Singapore History Museum) is the island's largest museum and its modernist extension gives it a revitalized appearance. The older parts showcase a striking building topped by a stained glass dome. It was previously the Raffles Museum and Library, renowned for its collections of ethnology, archaeology and natural history. In addition to its natural history drawings there are permanent galleries on Singapore's history, film, photography, food and fashion. It is also the custodian of Singapore's 11 National Treasures which include the Singapore Stone dating to the 13th century.

Learn more about Singapore's Peranakan community at the Peranakan Museum. Originally a school, this Neo-Classical building is now home to the Peranakans of mixed Chinese and Malay marriage. There are ten displays with information on Peranakan culture from dress to jewellery, costumes, food, language and religion.

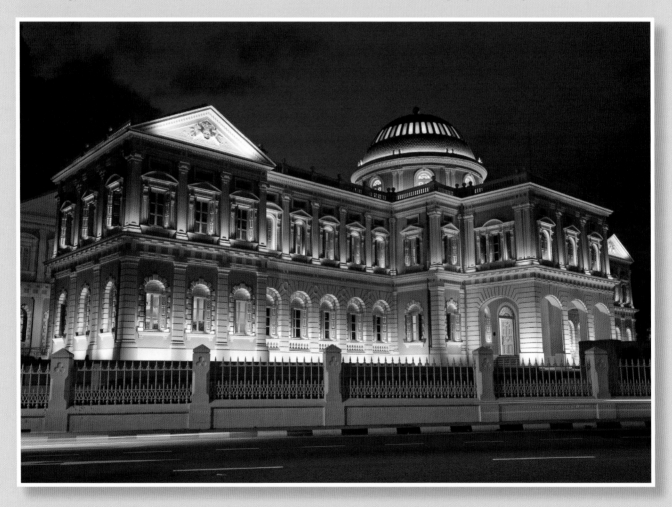

Above: The National Museum of Singapore dates back to 1849 and focuses on history. One of the popular sections details the history of food. An old bicycle (opposite) was typically used by hawkers who cycled around their neighbourhood selling a variety of food items.

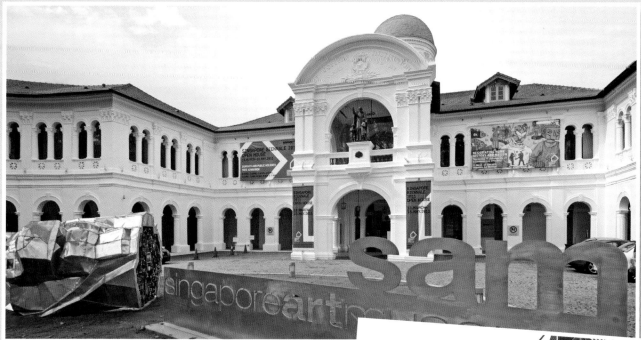

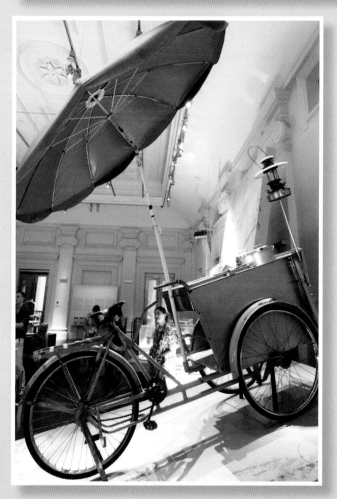

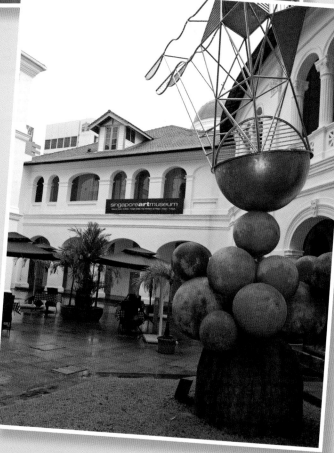

Top and above: The Singapore Art Museum is located in a former boys' school and is now a showcase for contemporary Asian art.

Resorts World Sentosa

Singapore's tourism profile changed dramatically with the opening of two integrated resorts - Resorts World Sentosa and Marina Bay Sands that offer a range of facilities and attractions from accommodation to theme parks and everything in between.

Resorts World Sentosa on Sentosa Island is home to hotels like Hard Rock Hotel and attractions like Universal Studios, Marine Life Park, Maritime Experiential Museum and Aquarium, and FestiveWalk.

Marine Life Park is the world's largest oceanarium. It houses and incredible 100,000 marine organisms and provides an interactive and multi-sensory experience. Visitors can snorkel with rays and wade through pools containing colourful reef fish. For fun-seekers there are lots of thrills and spills in rides such as the 620-m (2,034-ft) Adventure River as well as slides and wave pools.

FestiveWalk with its shopping, restaurants and bars in the resort completes the attractions.

Top, below and opposite: Relive Hollywood blockbusters in the seven zones of fun in Asia's first Universal Studios theme park including Hollywood, New York, Sci-Fi City, Ancient Egypt, Lost World, Far Far Away and Madagascar. There are 28 movie-themed rides and attractions, 18 of which have been designed exclusively for Singapore.

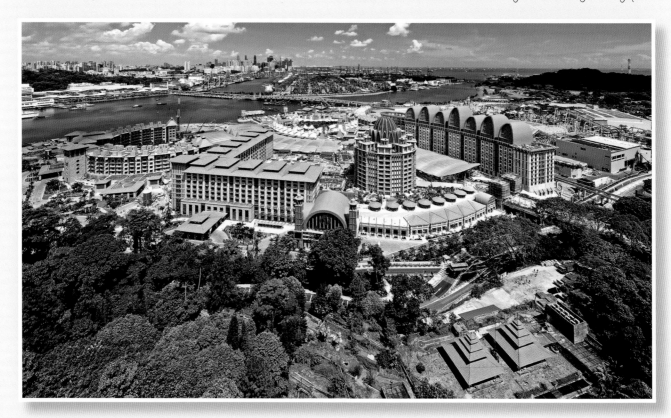

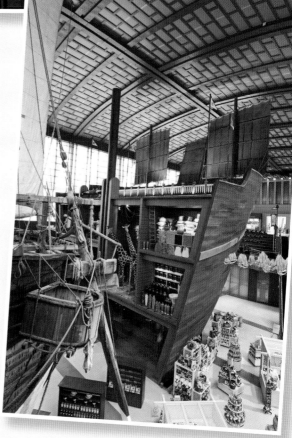

Above: The Maritime Experiential Museum and Aquarium is a showcase of the maritime trade between the East and West featuring early Chinese trader Admiral Zheng He and his treasure ship, the Bao Chuan.

Marina Bay Sands and ArtScience Museum

Marina Bay Sands is Singapore's other integrated resort which also provides gaming outlets, entertainment, shopping, dining, theatres, convention facilities and recreational opportunities. It is an architecturally impressive structure designed by renowned architect Moshe Safdie featuring three hotel towers with 2,500 rooms connected at the top by one of the world's largest cantilevers. Located 200 m (656 ft) above Marina Bay, the 340-m (1,115-ft) long Sands SkyPark offers gardens, a swimming pool, restaurants and bars all with 360° views. An observation deck is accessible to the general public for a fee.

Dining is important in Singapore and Marina Bay Sands satisfies the cravings of its visitors with a range of outlets including the restaurants of seven international celebrity chefs plus numerous other options.

This page: The futuristic architecture of Marina Bay Sands dominates the skyline around the bay in central Singapore. 'The Shoppes' within the complex has 270 retail outlets including many well recognized brands. There are also restaurants and a 600-m² (6458-sq. ft) indoor ice skating rink.

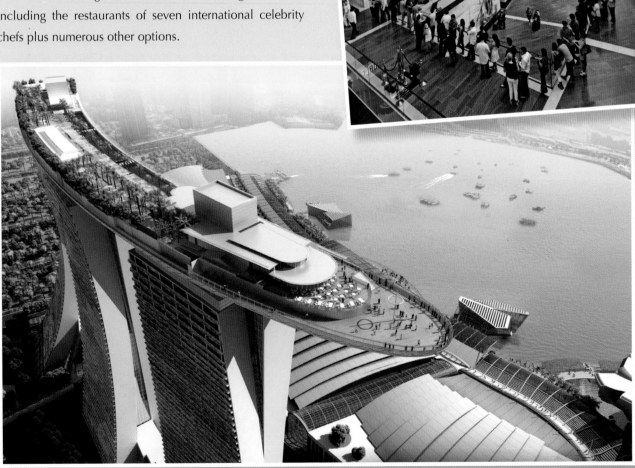

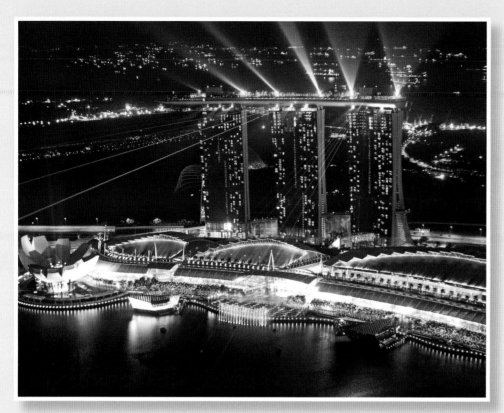

Left: Each evening the complex stages a spectacular laser light show that is best seen from around Marina Bay.

Below: Near the base of the three towers is the equally impressive ArtScience Museum. Designed as a symbolic gesture of welcome it resembles a lotus flower and celebrates art, science, technology, design and architecture. Its permanent exhibition is "A Journey Through Creativity".

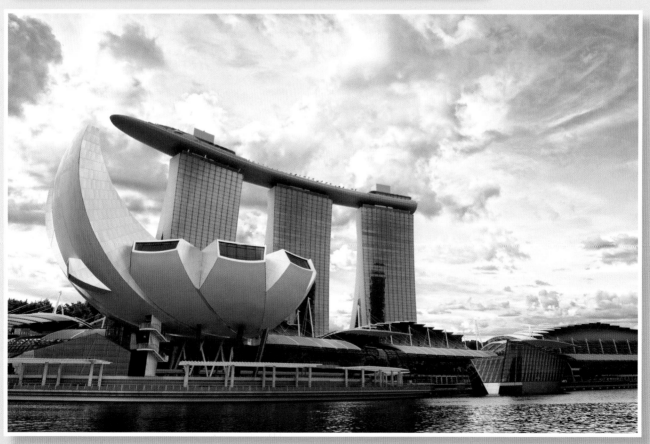

Science Centre Singapore

The main aim of the Science Centre Singapore is to make science exciting and inspiring for everyone. It covers 20,000 m² (215,280 sq ft) of indoor and outdoor space with over 1,000 interactive exhibits housed within 14 galleries featuring a range of topics related to science, mathematics and technology.

There are lots of exciting hands-on, interactive exhibits for children, such as the Fire Gallery, Earth Our Untamed Planet and Uniquely U exhibitions and organized community events such as star-gazing.

Close by, the Omni Theatre is home to an IMAX theatre which screens educational movies. It has a five-storey high hemispheric screen and wraparound digital surround-sound. Topics include science, space, nature, animals, culture and disasters.

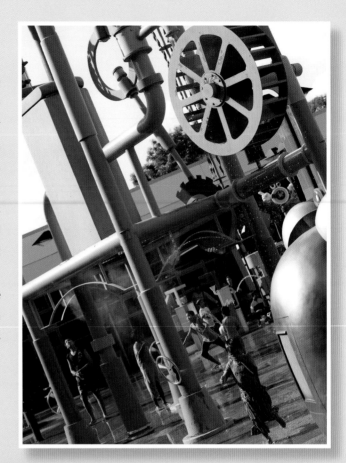

Top: The Science Centre is full of interactive displays. In 'Waterworks', visitors can discover intriguing facts about the element and its importance in everyday life. Be prepared to get wet!

Right: The Science Centre is a lot of fun but is also ideal for those who want to learn more about how science works and how it affects our lives. In the Technology Gallery there are lots of machines and gadgets for children to play with, while learning the principles of science at the same time.

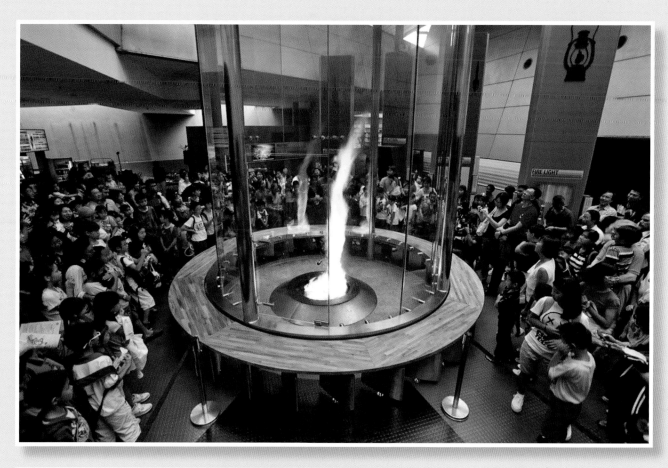

Top: 'Fire Tornado' introduces one of the most terrifying and spectacular phenomena in nature. The display is located in a specially built enclosure within the Science Centre.

Left: Snow is impossible in the tropics (Singapore's coldest day on record is 19.4°C/70°F) so Singapore's first permanent indoor snow centre, Snow City next to the Science Centre was designed to recreate snow. Within it 'Snow Quest' offers a complete package of snow sports on a three-storey high and 60-m (197-ft) long ski slope.

Chapter 4: Characterful Districts

For a small island Singapore has many districts and attractions ranging from ethnic precincts to modern integrated resorts. Certain neighbourhoods have distinctly different characters based upon the island's three main ethnic communities of Chinese, Malay and Indian. Singapore successfully retains many heritage precincts while forging ahead with rapid modernization.

Chinatown

Chinatown is home to the most dominant ethnic community in Singapore. While it, too, has been affected by contemporary life, many parts haven't changed over time. Traditional activities can still be found with cobblers, medicine shops, tea houses, jade jewellers and foot reflexologists offering a colourful kaleidoscope, however, souvenir sellers tend to dominate. Temple Street is an atmospheric street to explore and nearby, Maxwell Food Centre is the place to savour delicious Chinese hawkerstall dishes. A visit to the Chinatown Heritage Centre on Pagoda Street will reveal more of the origins of Chinatown. This interactive museum traces the history of various Chinese communities that emigrated from China.

In line with Singapore's multiculturalism, Chinatown is not an exclusive Chinese domain but also home to places of worship like Sri Mariammam Temple (Singapore's oldest Hindu temple founded in 1827) and Masjid Jamae.

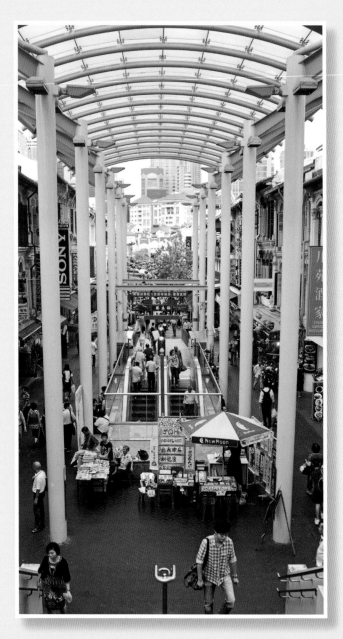

Right: In addition to all the attractions and old buildings in Chinatown, shopping is another reason for visitors to come here. Most will arrive via the Chinatown MRT Station which has its main entrance on Pagoda Street. The street is named after Sri Mariammam Temple, Singapore's oldest and largest Hindu place of worship located along the street.

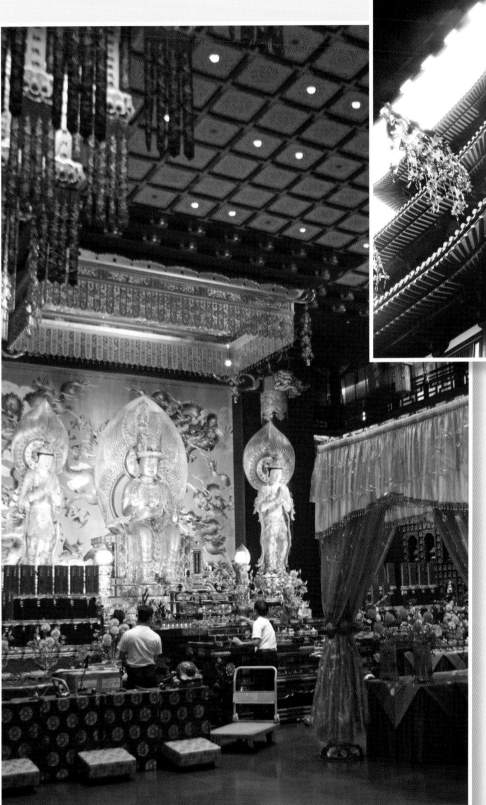

This page: The Buddha Tooth Relic Temple has fascinating architecture. It was built in 2002 in the Tang Dynasty architectural style. Although it's called a temple it actually offers much more being, in fact, a cultural centre that includes a library, a theatre, a dining hall and a museum in addition to housing the Buddha relic. The sacred tooth is located on the fourth floor. With over 12,000 Buddha images here, it is a hugely popular place of worship.

Duxton Hill and Tanjong Pagar

The adjoining districts of Duxton Hill and Tanjong Pagar are an extension of Chinatown. Now conservation areas, many renovated shophouses line the narrow streets. What were once mostly homes are now restaurants, bars and cafés, although some still retain their original Chinese coffeeshop atmosphere.

The shoplots built from 1840 to 1900 are somewhat plain, two-storey buildings. In the early 1900s the architectural style changed with the addition of a third floor. Architects refer to a "Late Style" dating from 1900 to 1930 and including buildings exhibiting flamboyant ornamentation. This was followed by simpler styles during the Great Depression. Afterwards and up until the 1960s, "Art Deco Style" is typified by classical geometric motifs. Bukit Pasoh Street is representative of these architectural styles. Some, like the New Majestic Hotel, attract design-conscious travellers as each room is individually decorated.

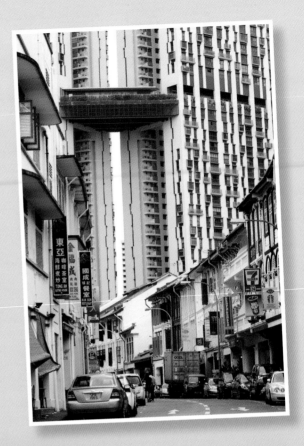

Above: Pinnacles@Duxton, an iconic Housing Development Board project, provides a stark contrast between the district's new and old parts.

Right: Duxton Hill has had several transformations over time and while bars still exist in the area it has become more genteel since many restaurants, cafés, galleries and bookshops have opened.

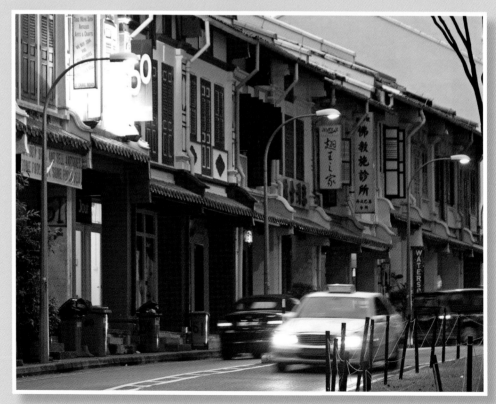

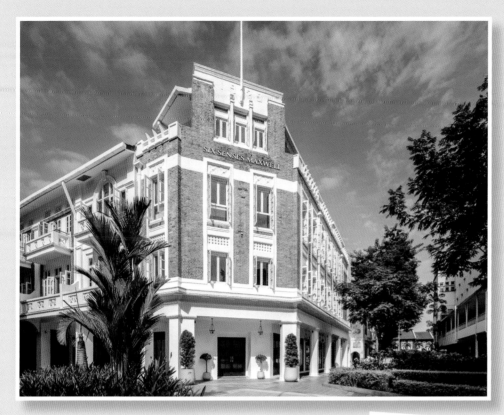

Left: Several old shoplots in Duxton Hill have been converted to boutique hotels, such as the luxury Six Senses Maxwell.

Bottom left: Duxton Hill and the greater Tanjong Pagar area became Singapore's first conservation zones to protect the two to three-storey shoplots.

Bottom right: The New Majestic Hotel is a designer-room property that also includes a modern Cantonese restaurant and an innovative bar.

Little India

Visitors could be forgiven for thinking they were in the streets of New Delhi as the distinctive aromas of Indian spices, oils and cooking waft through Little India. Colourful altar garlands are sold from stalls surrounding several temples and Bollywood music dominates the airwaves. Jewellery stores glisten with golden items traditionally given as wedding gifts and to loved ones as an investment and proof of status. Like Chinatown, there is a vibrant and energetic atmosphere that makes it an essential visit with plenty of restaurants to keep hunger at bay. The streets are especially busy and colourful during the festivals of Thaipusam, Deepavali and Ponggal (the latter being a southern India festival related to a bountiful rice harvest).

Visit the hawkerstalls and wet market in Tekka Centre to discover the fresh food delights that are not all entirely Indian, while Little India Arcade offers a treasure trove of all things Indian including intricate textiles.

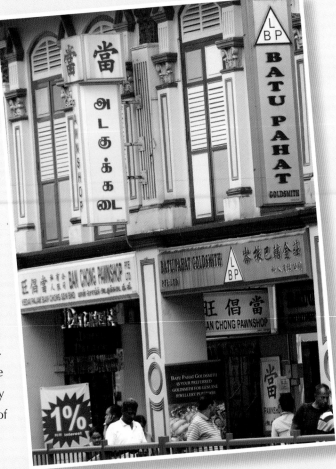

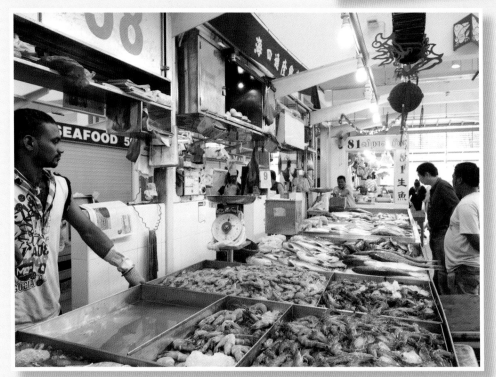

Above: The streets of Little India reverberate with a cacophony of sounds and a riot of colour.

Left: The Tekka Centre has a wet market where fresh produce such as seafood, fruit and vegetables flown in from Sri Lanka and India are sold. There are also stalls selling 'dry' produce plus textile and clothing shops. It's a popular place for a casual meal bought from hawkerstalls offering a variety of delicious dishes from India, China and Malaysia.

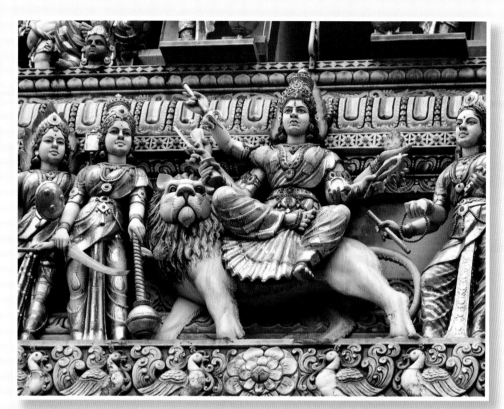

Left: Sri Veeramakaliamman Hindu Temple is the most ornate of the Hindu temples. Dating from 1881, it is dedicated to the goddess Kali who maintains world order and destroys ignorance. The temple is crowded on the holy days of Tuesdays and Fridays.

Below: The restored Abdul Gafoor Mosque is resplendent in cream and green paint and, despite ornate European-styled columns, its minarets reflect Indian Muslim architecture.

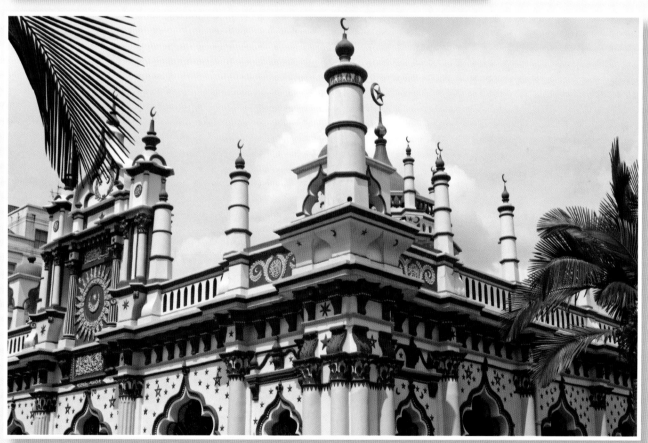

Kampong Glam

Kampong Glam is one of the centres for Singapore's Muslim community; its name is a derivation of the Malay words for village and gelam (the tree *Melaleuca cajuputi Powell* that once grew here). The land was originally given to Johor's Sultan Hussein Shah as part of the arrangement for the British ceding Singapore. He built his palace here and called it Istana Kampong Glam. Nearby on Muscat Street he constructed the original Sultan Mosque in 1826 and it became a place for worship. The palace converted to the Malay Heritage Centre (Taman Warisan Melayu) in 2004. Bussorah Mall leads out from the entrance of the mosque. There are many food outlets along the pedestrian-only area.

Bugis Street is located nearby on the other side of Rocher Canal Road and it, too, is brimming with bazaars. Now a cobble-stoned area it offers Singapore's largest street shopping precinct.

Right: *A narrow street called Haji Lane has become a centre for trendy young designers who have opened up quirky outlets to sell their creations. Nearby is Arab Street, a location for traditional shops selling textiles and religious articles.*

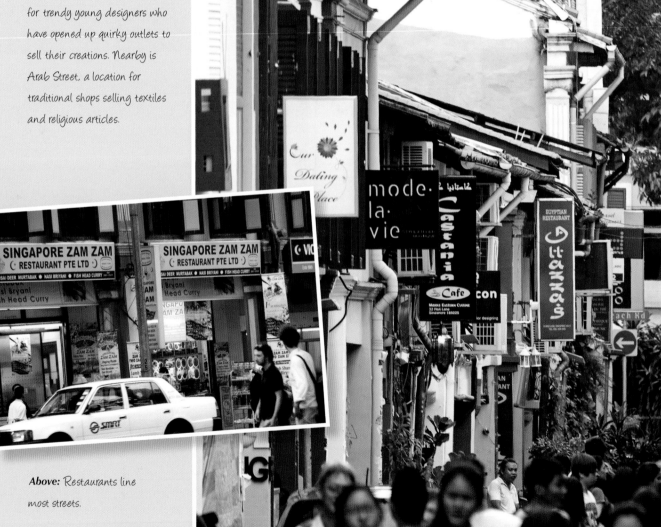

Above: *Restaurants line most streets.*

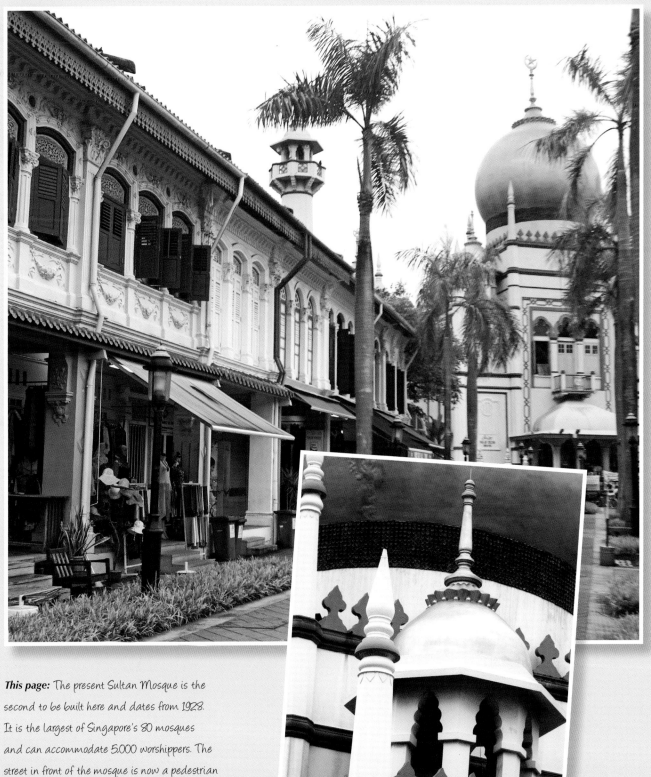

This page: The present Sultan Mosque is the second to be built here and dates from 1928. It is the largest of Singapore's 80 mosques and can accommodate 5,000 worshippers. The street in front of the mosque is now a pedestrian area lined with shops and cafés which mostly sell halal food. It is a popular meeting area especially after prayers.

Orchard Road, Emerald Hill and Peranakan Place

Orchard Road is Singapore's premier retail street with shopping centres extending from Orchard Parade at the top of Tanglin Road eastward to the base of Fort Canning. Midway down the bustling strip are the tranquil oases of Peranakan Place and Emerald Hill.

With over 20 shopping malls on Orchard Road, there's enough here to occupy ardent shoppers. Restaurants, cafés and cinemas add to the mix. Tall trees meet in the middle to cast shade down the one-way road and are hung with Christmas decorations every December. The majestic gates of the Istana mark the entrance to the official residence of the Singapore President. While mostly off limits, the Istana grounds are open to the public on five days of the year.

Right: On the area's eastward extremity, the former convent now called Chijmes is home to shops, bars and restaurants with the former chapel being a functions venue. The former Catholic convent school also includes a Gothic-styled chapel with dominant flying buttresses. It is now protected as a national monument housing an art gallery and entertainment facilities.

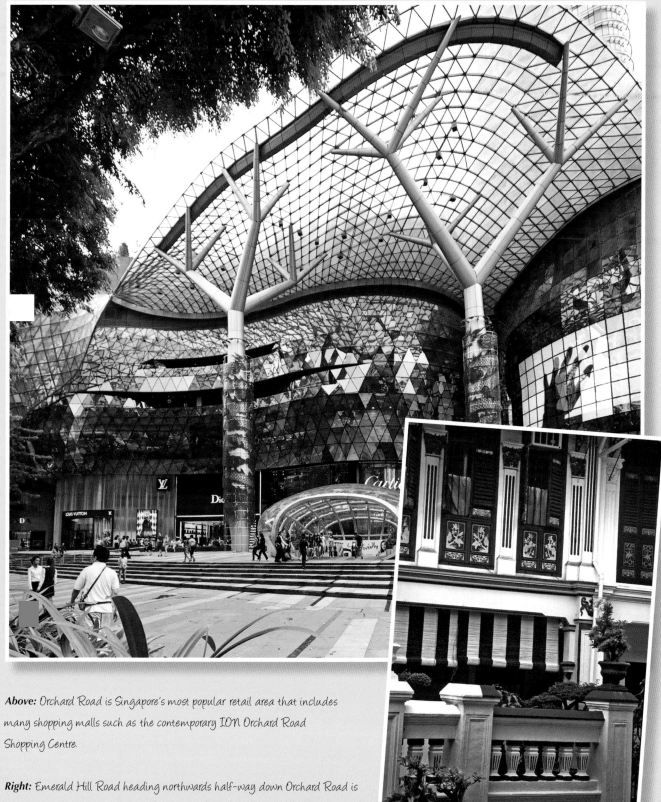

Above: Orchard Road is Singapore's most popular retail area that includes many shopping malls such as the contemporary ION Orchard Road Shopping Centre.

Right: Emerald Hill Road heading northwards half-way down Orchard Road is home to bars and restaurants in Peranakan Place and historic Peranakan-styled terraces further up the street.

Marina Bay and the Financial District

Just east of the city centre, the 360-ha (890-acre) Marina Bay of mostly reclaimed land is a mix of commercial, residential, recreation, hotel and entertainment activity as well as Marina Bay Sands (see page 54). Parts of Marina Bay have been transformed into a freshwater reservoir with the completion of the Marina Barrage. The bay is surrounded by parkland and recreational space and what is now a dam for watersports.

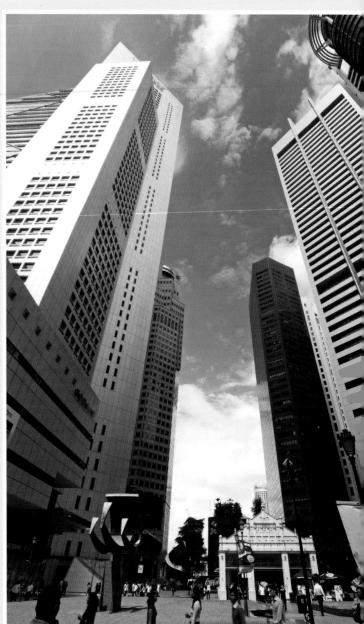

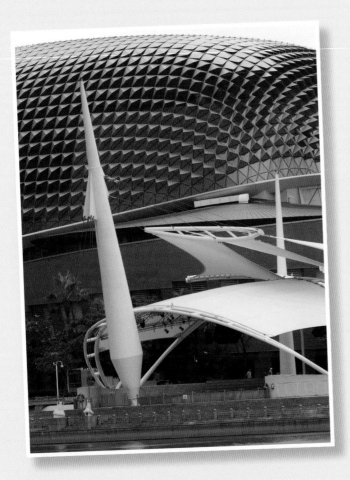

Above: Theatres on the Bay has an outer roof lining that resembles the thorny skin of a durian. It is home to performance art, concerts and galleries. Leading shopping centres such as Suntec City, Raffles City and Marina Square are located in the area.

Above: Raffles Place is testament to Sir Stamford Raffles vision of Singapore as a great commercial emporium. What was originally a peaceful village green is now dominated by towering mirrored-glass buildings that typify the island's booming economy.

Right: The Singapore Flyer, the world's largest observation wheel rises 165 m (541 ft) above Bay Central. 28 capsules each holding 28 passengers take flight to ensure an enchanting downtown view.

Below: The financial district is the headquarters for many local, regional and international businesses.

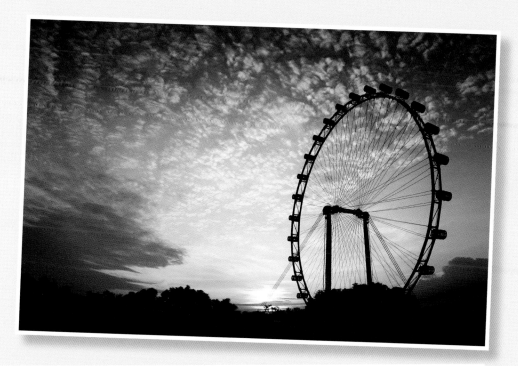

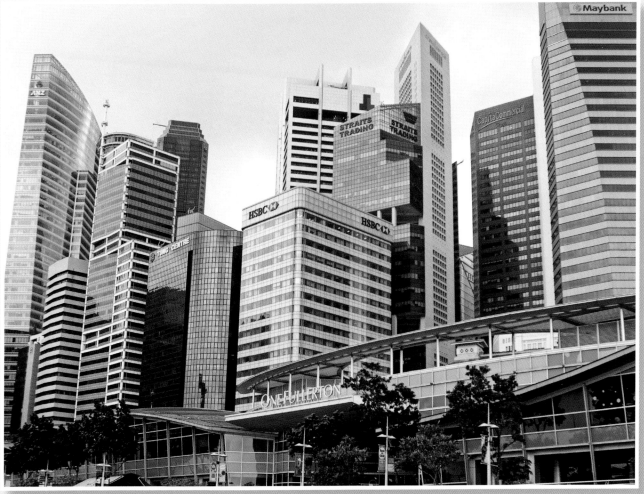

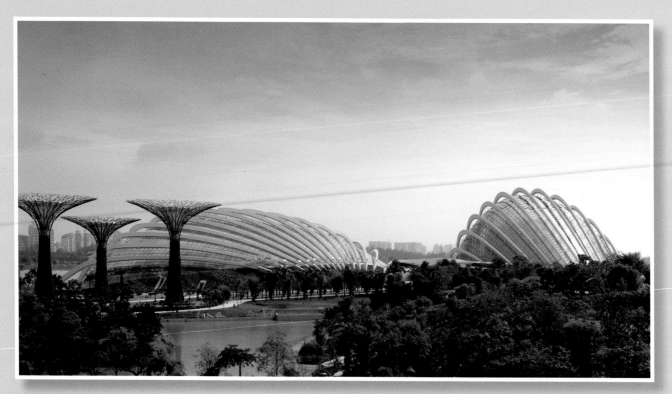

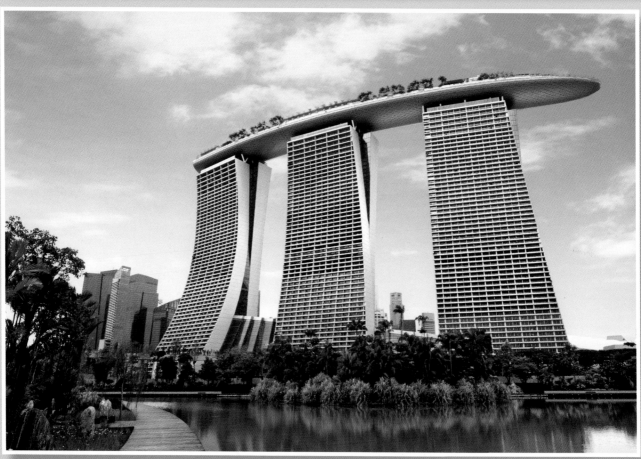

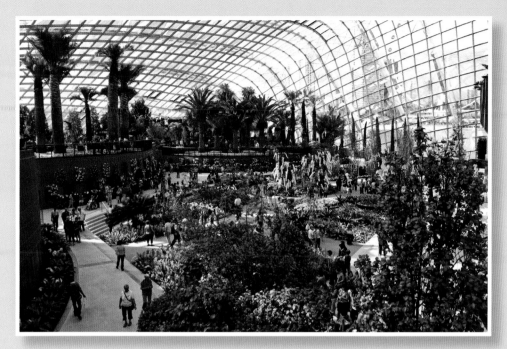

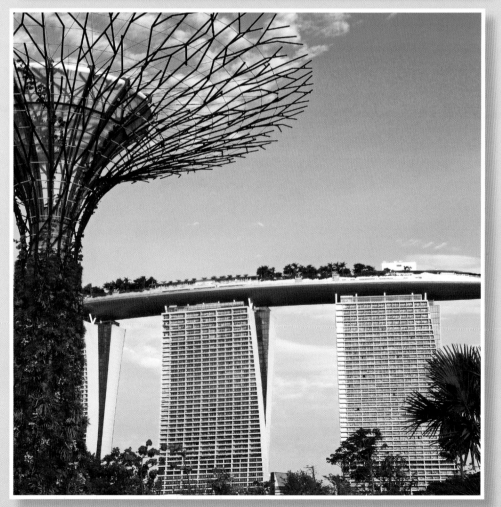

Opposite top, left and below left: Gardens by the Bay is an ambitious development that is contributing to Singapore's transformation into a "City in a Garden". Undertaken by the National Parks Board, it occupies 101 ha (249 acres) of prime waterfront land and includes three distinctive waterfront gardens – Bay South, Bay East and Bay Central. Bay Central has a 3-km (1 mile) long waterfront promenade linking the other two gardens. Bay East of 32 ha (79 acres) includes food gardens, a watersports arena, water gardens and edutainment areas. Bay South is the largest garden at 54 ha (133 acres) and includes the massive Conservatory Complex (two glasshouses showcasing plants from Mediterranean-type climatic regions and tropical mountains), 18 Supertrees (nine to 16 storeys high, tree-like, vertical gardens), aerial walkways, a treetop bistro and themed gardens.

Opposite below: Marina Bay Sands fronts the Gardens by the Bay.

Singapore River and Quays

The Singapore River and the Clarke, Robertson and Boat quays are excellent examples of urban renewal where former *godowns* (warehouses) have been refurbished and converted into trendy restaurants, cafés and bars. In most cases, other buildings which were pre-war shoplots have at least had their façades preserved.

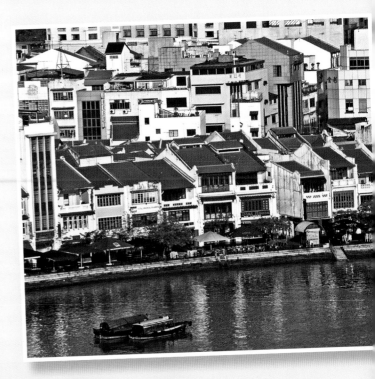

Below: Boat Quay on the southern bank was once the centre of the city's commercial activity. When shipping technology changed to containerization, the godowns fell into disrepair until 1986 when a government conservation project transformed them.

Right: The area around Boat Quay is a far cry from when Sir Stamford Raffles first sailed up the Singapore River with its small fishing village located amongst mangroves and thick rainforest.

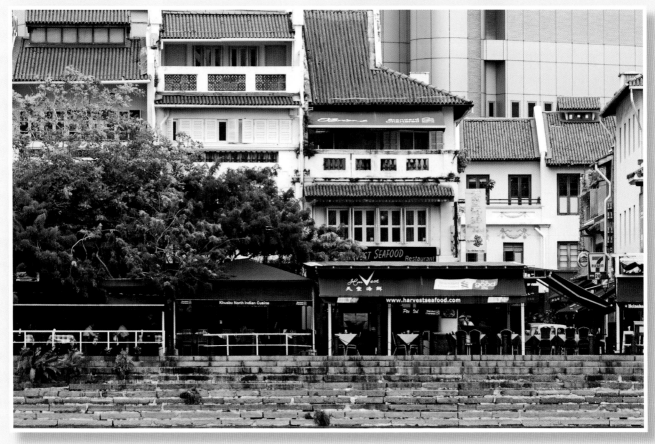

Left: Clarke Quay on the northern bank is named after Sir Andrew Clarke, Singapore's second governor. It is best visited in the evening when things swing into top gear. Its water fountain underneath the sail-like roof changes colour and adds to the atmosphere.

Below: Wooden bumboats which once carried cargo from ships moored offshore now ferry tourists along the river with stops at the quays. This is one of Singapore's most popular tourist activities.

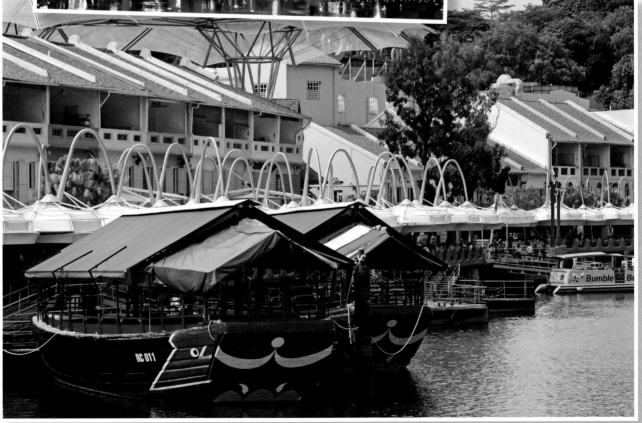

Sentosa Island

Sentosa Island should be renamed Adventure Island as it is a playground for Singaporeans. Covering 504 ha (1,245 acres) it is home to Resorts World Sentosa (see page 52), Underwater World Singapore (see page 38), 11 resorts, a marina, a museum, golf courses, beaches, forest trails and an exciting range of activities, such as the MegaZip Adventure Park (flying fox, rope course and zip line), Jewel Cable Car Ride, the 131-m (429-ft) high Tiger Sky Tower, Butterfly Park, Fort Siloso (a former coastal fort) and iFly, the world's largest wind tunnel for indoor skydiving.

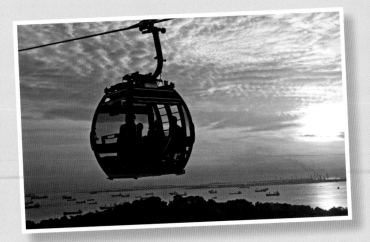

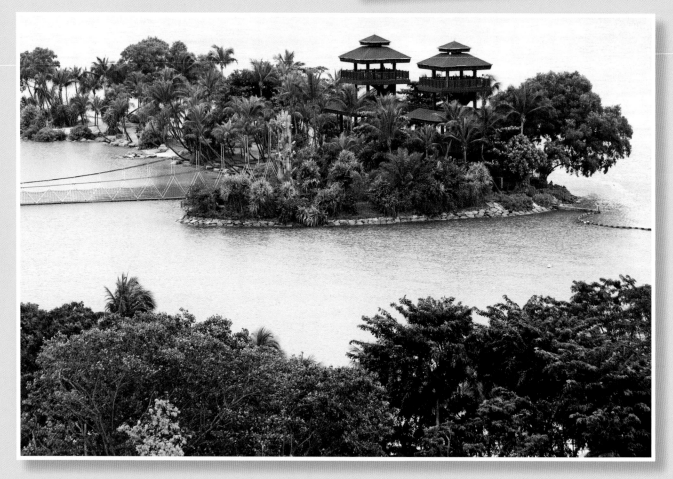

Above: Palawan Beach is connected to Sentosa Island via a suspension bridge. Several nearby bars and restaurants ensure this is a popular playground for relaxation and recreation.

Top: A causeway, the Sentosa Express monorail and a 1.65-km (1-mile) long cable car from Mount Faber on the mainland connect to the island. There are good views of the island and Singapore from Imbiah Lookout and by ascending the replica Merlion.

Right: The facilities at the beaches on Sentosa Island are well developed and are popular for a variety of activities both in the water and on the sands amongst swaying coconut palms.

Below right: Wave House Sentosa is a simulated surfing experience ideal for learning to surf or boogie board. There's also a restaurant, bar and beachside relaxation.

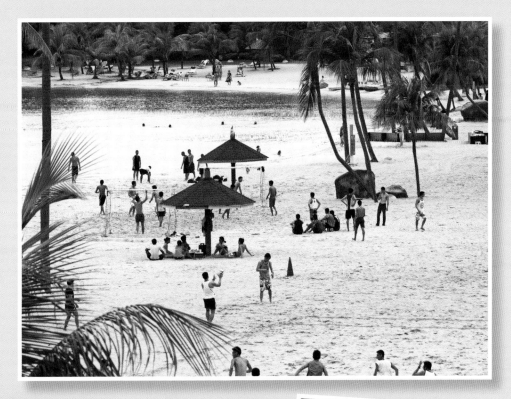

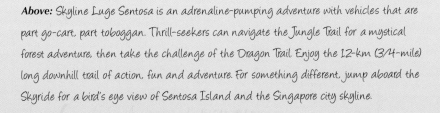

Above: Skyline Luge Sentosa is an adrenaline-pumping adventure with vehicles that are part go-cart, part toboggan. Thrill-seekers can navigate the Jungle Trail for a mystical forest adventure, then take the challenge of the Dragon Trail. Enjoy the 1.2-km (3/4-mile) long downhill trail of action, fun and adventure. For something different, jump aboard the Skyride for a bird's eye view of Sentosa Island and the Singapore city skyline.

Getting About

Singapore is connected to the world via Changi International Airport which is consistently ranked one of the world's best and busiest airports. There are several Singapore-based commercial airlines operating to and from Singapore including SilkAir, Jetstar, Scoot and Singapore Airlines. Seletar Airport is a smaller airport with facilities for private jets, aerospace activities and repairs.

Operated by Malaysia's KTM, international trains head from Woodlands northwards across the causeway into Malaysia and onto Thailand. The former line through to Tanjong Pagar has been closed and all Malaysian trains now terminate at Woodlands. The luxurious Eastern and Oriental Express (E & O) train operates from Singapore to Bangkok via Malaysia with several monthly departures.

Trains and cars share the causeway access while on the extreme northwestern side of Singapore another border crossing via a bridge is located at Tuas.

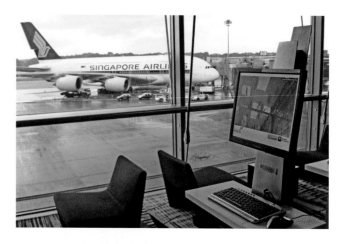

Above: Singapore Airlines, the national carrier, flies to destinations on six continents from its base at Changi International Airport using aircraft such as the Airbus A380.

Left: Singapore's Mass Rapid Transit (MRT) is a train system that provides fast and efficient access to the island's main attractions.

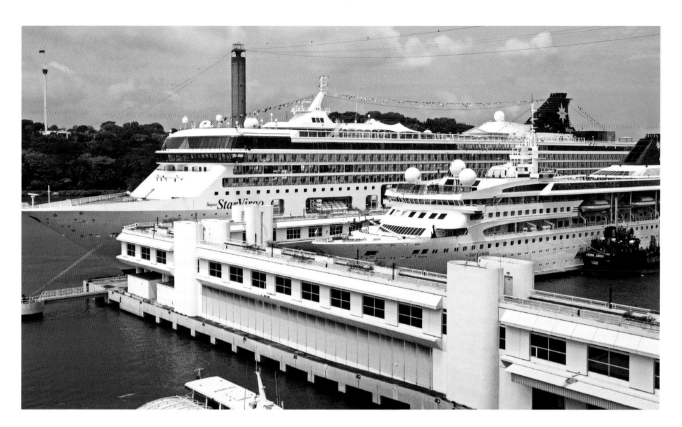

Cruise ships visiting Singapore moor at the cruise centre opposite Sentosa Island. It is also possible to travel from Singapore to neighbouring Malaysia and Indonesia on ferries.

Singapore has an excellent road and highway system with automatic e-tolls on the major roads. Cars travel on the left-hand side of the road and road signs are in English. An efficient bus, train and taxi service completes the public transport network. Singapore's Mass Rapid Transit (MRT) trains provide good access to Singapore's tourist attractions, downtown area and the airport. Many Singaporeans do not own a car and happily use public transport to get around.

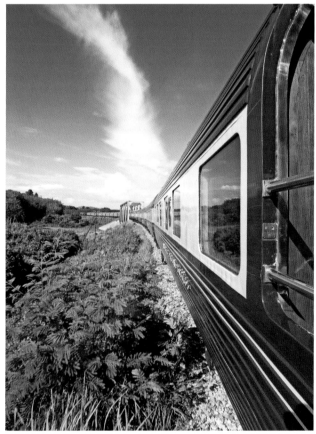

Above: An increasing number of tourists arrive or depart from the HarbourFront Cruise and Ferry Terminal for trips on cruise ships throughout the region.

Right: The Eastern & Oriental Express starts its northerly journey from Singapore travelling to its final destination of Bangkok in Thailand.

Contact details

Useful websites

ArtScience Museum: www.marinabaysands.com.

Asian Civilizations Museum: www.acm.org.sg

Chinatown Heritage Centre:
www.chinatownheritagecentre.sg

Forest Adventure: www.forestadventure.com.sg

G-Max reverse bungee: www.gmax.com.sg

ifly: www.iflysingapore.com

National Museum of Singapore: www.nationalmuseum.sg

National Parks Board: www.nparks.gov.sg

Peranakan Museum: www.peranakanmuseum.sg.

Sentosa Luge: www.hg.sg/sentosa/lugewave

Singapore Art Museum (SAM):
www.singaporeartmuseum.sg.

Singapore Flyer: www.singaporeflyer.com

Singapore Tourism Board: www.stb.gov.sg

The Arts House: www.theartshouse.com.sg

Wave House Sentosa: www.wavehousesentosa.com

Contact details for parks and other attractions:

Bukit Timah Reserve; Tel: +65 6542-778;
www.nparks.gov.sg.

Jurong Bird Park; Tel: +65 6265-0022;
www.birdpark.com.sg.

Marina Bay Sands; Tel: +65 6688-8868;
marinabaysands.com

NParks Visitors' Centre; Tel: +65 6332-1200;
www.nparks.gov.sg

Resorts World Sentosa; Tel: +65 6577-8888;
www.rwsentosa.com

Science Centre Singapore; Tel: +65 6425-2500;
www.science.edu.sg.

Singapore Botanic Gardens; Tel: +65 6471-7361;
www.sbg.org.sg.

Singapore Zoological Gardens; Tel: +65 6275-0030;
www.zoo.com.sg.

Sungei Buloh Wetland Reserve; Tel: +65 6794-1401;
www.sbwr.org.sg.

Underwater World Singapore; Tel: +65 6275-0030;
www.underwaterworld.com.sg.

Airlines

Jetstar: www.jetstar.com

Scoot:www.flyscoot.com

SilkAir: www.silkair.com

Singapore Airlines: www.singaporeair.com

Acknowledgments

The author would like to thank Singapore Tourism for its kind assistance especially Garry Koh and Mary-Ann Chong. Dr Geoffrey Davison and David Li provided valuable input on the natural sections of the book.

The publishers and the author would like to express special thanks to Ken Scriven (1928-2018) for his advice and support during the preparation of this book and many others.

About the Author

David Bowden is a freelance photojournalist based in Malaysia who specializes in travel and the environment. While Australian, he's been in Asia for longer than he can remember and returns to his home country as a tourist. When he's not travelling the world, he enjoys relaxing with his equally adventurous wife, Maria, and daughter, Zoe. He is also the author of several other books in this series.

Index

Abdul Gafoor Mosque 63
Air travel 76
Albert Court Village Hotel 49
Animals 19, 22–25, 34, 36–37, 42–43
Arab Street 64
Architecture 44, 54–55, 59, 60, 63
ArtScience Museum 54–55
Arts House, The 9, 44
Association of South-East Asian Nations (ASEAN) 6
Bao Chuan treasure ship 53
Battle Box, The 46, 47
Bay Central 69, 71
Bay East 71
Bay South 71
Beach Road 48
Bedok Reservoir 30
Birds 19, 22, 25, 35, 40–41
Boat Quay 72
Botanic Gardens 3, 32–33
Buddha Tooth Relic Temple 13, 59
Bugis Street 64
Bukit Kalang 42
Bukit Pasoh Street 60
Bukit Peirce 42
Bukit Timah 7, 17, 20, 42–43
Bussorah Mall 64
Cable car 39, 74
Canning, Viscount 46
Central Catchment Nature Reserve 17, 19, 42
Changi Beach 19
Changi International Airport 5, 30
Chijmes 66
Chinatown 4, 13, 30, 58–59
Chinatown Heritage Centre 58
City Hall 44
Clarke Quay 3, 72, 73
Clarke, Sir Andrew 73
Climate 7
Conservatory Complex 71
Corals 19
Cruise ships 77
Cuisine 14–15
Dolphin Lagoon 38, 39
Duxton Hill 60–61
East Coast Parkway 30
Eastern and Oriental Express 76, 77
Emerald Hill 66–67
Empress Place 44–45
Fauna 22–25, 34, 36–37
Ferries 77
Festivals 12–13, 62
 Chinese New Year 12, 13
 Christmas Day 13
 Deepavali 13, 62

Festival of the Hungry Ghosts 13
Good Friday 13
Hari Raya Puasa 12
Mooncake and Lantern Festival 13
National Day 13
New Year 4, 13
Ponggal 62
Ramadan 12
Thaipusam 12, 62
Wesak (Vesak) Day 13
FestiveWalk 52
Financial District 68–71
Flora 20–21, 42
Food 14–15
Forest Adventure 29, 30
Forests 18–19, 42
Formula 1 Grand Prix 4, 28
Fort Canning 46–47, 49
Fort Gate 47
Galleries, see Museums and galleries
Gardens by the Bay 1, 70–71
Geography and climate 6–7
Glutton's Corner 14
Goodwood Park Hotel 49
Great Singapore Sale 30
Haji Lane 64
HarbourFront Cruise and Ferry Terminal 77
Hard Rock Hotel 52
Heritage hotels 48–49
History 8–9
Hotels 48–49
Housing Development Board 10, 60
Istana 66
Istana Kampong Glam 64
Johor Bahru 6
Jurong Bird Park 3, 40–41
Kampong Glam 4, 14, 64–65
Katong 8
Labrador Nature Reserve 17, 19
Land and resources 26–27
Languages 10
Lee Kuan Yew 9
Little India 4, 30, 62–63
Lower Peirce Reservoir 42
MacRitchie Reservoir 16, 17, 42
Malay Heritage Centre 64
Mangroves 18, 19
Marina Barrage 68
Marina Bay 4, 54, 55, 68–71
Marina Bay Sands 4, 54–55, 70
Marina Square 58
Marine life 19, 38–39
Marine Life Park 52

Masjid Jamae 58
Mass Rapid Transit (MRT) 76, 77
Maxwell Food Centre 48
Merlion 5
Moshe Safdie 54
Mount Faber 38, 39, 74
Muscat Street 64
Museums and galleries 50–51
 ArtScience Museum 54–55
 Asian Civilizations Museum 44, 50
 Maritime Experiential Museum and Aquarium 52, 53
 National Art Gallery of Singapore 44
 National Museum of Singapore 50
 Peranakan Museum 50
 Singapore Art Museum 50, 51
National Parks Board 30, 71
Natural habitats 16–19
Nee Soon Swamp Forest 19
New Majestic Hotel 60, 61
Ngee Ann City 31
Night Safari 36
Old Parliament House 44, 45
Omni Theatre 56
Orchard Road 30, 31, 32, 46, 66–67
Padang 30, 44, 45
Pagoda Street 58
Palawan Beach 74
People 10–13
 Chinese 10, 11, 12, 58
 Eurasian 10
 Indian 10, 58
 Malay 10, 58
 Peranakan 8, 10
People's Action Party 9
Peranakan Place 66–67
Percival, General 46
Plants 20–21, 42
Quays 3, 72–73
Raffles City 68
Raffles Hotel 15, 48
Raffles Landing Place 44
Raffles Place 3
Raffles, Stamford 8, 44, 47, 58, 72
Religion 10, 12–13, 58, 59, 63, 65
Resorts World Sentosa 4, 52–53, 74
River Safari 36
Road travel 76–77
Robertson Quay 72
Rocher Canal Road 64
St Andrews Anglican Cathedral 44

Sands SkyPark 54
Sarkies Brothers 48
Science Centre Singapore 56–57
Scotts Road 49
Semakau Island 19
Sentosa Express monorail 74
Sentosa Island 5, 28, 38, 39, 74–75
Shopping 4, 30–31, 52, 54, 58, 64, 66–67, 68
Singapore Botanic Gardens 3, 32–33
Singapore Cricket Club 44
Singapore Flyer 59
Singapore River 44, 47, 72–73
Singapore Sling cocktail 15, 48
Singapore Zoo 22, 36–37
Ski 360° 29, 30
Spice Garden, The 47
Sports and lifestyle 28–31
Sri Mariammam Temple 58
Sri Perumal Temple 13
Sri Thandayuthapani Temple 13
Sri Veeramakaliamman Hindu Temple 63
Straits of Johor 6, 7
Straits Settlements 9
Sultan Hussein Shah 64
Sultan Mosque 64, 65
Sungei Buloh Wetland Reserve 17, 19, 22, 34–35
Suntec City 68
Supreme Court 44
Tai chi' 10
Takashimaya Shopping Centre 31
Taman Warisan Melayu 64
Tanjong Pagar 26, 27, 60–61
Teh tarik 15
Tekka Centre and Market 14, 62
Temple Street 58
Timah Hill, see Bukit Timah
Train travel 76–77
Travel 76–77
Tuas 7
Underwater World Singapore 38–39, 74
Universal Studios 27, 52, 53
Upper Peirce Reservoir 42
Upper Seletar Reservoir 42
Victoria Theatre and Concert Hall 44, 45
Zheng He, Admiral 53
Zoological Gardens, see Singapore Zoo

This edition published in the United Kingdom in 2019 by John Beaufoy Publishing,
11 Blenheim Court, 316 Woodstock Road, Oxford OX2 7NS, England
www.johnbeaufoy.com

10 9 8 7 6 5 4 3 2 1

Great care has been taken to maintain the accuracy of the information contained in this work.
However, neither the publishers nor the author can be held responsible for any consequences arising from
the use of the information contained therein.

ISBN 978-1-912081-06-6

Designed by Glyn Bridgewater
Cartography by William Smuts
Project management by Rosemary Wilkinson

Printed and bound in Malaysia by Times Offset (M) Sdn. Bhd.